Art in Japanese
Esoteric Buddhism

.

Volume 8

THE HEIBONSHA SURVEY OF JAPANESE ART

For a list of the entire series see end of book

CONSULTING EDITORS

Katsuichiro Kamei, *art critic*
Seiichiro Takahashi, *Chairman, Japan Art Academy*
Ichimatsu Tanaka, *Chairman, Cultural Properties Protection Commission*

Art in Japanese Esoteric Buddhism

by TAKAAKI SAWA

translated by Richard L. Gage

New York • WEATHERHILL/HEIBONSHA • Tokyo

This book was originally published in Japanese by Heibonsha under the title *Mikkyo no Bijutsu* in the Nihon no Bijutsu Series.

A full glossary-index covering the entire series will be published when the series is complete.

First English Edition, 1972
Second Printing, 1976

Jointly published by John Weatherhill, Inc., of New York and Tokyo, with editorial offices at 7-6-13 Roppongi, Minato-ku, Tokyo 106, and Heibonsha, Tokyo.

LCC Card No. 70-162682 ISBN 0-8348-1001-8

Contents

Art in Japanese
Esoteric Buddhism

CHAPTER ONE

The Origins of Esoteric Buddhist Art

BUDDHIST ART IN general dates from the centuries before the dawning of the Christian era, but in Japan it did not really begin until the seventh century A.D., and in the early stages it centered on Mahayana doctrines and the historical Buddha Shaka (Sakyamuni). Mahayana, sometimes called Northern Buddhism, is the later, theistic form of the religion, developed in northern India and surviving today in China and Japan.

Early representations of Shaka were of him alone. Later, however, there were added statues or pictures of Bodhisattvas (in Japanese, Bosatsu), the Ten Great Disciples, the Eight Messengers, the Four Celestial Guardians, Taishaku Ten (Indra), Bon Ten (Brahma), and many guardian deities. Gradually, as more and more Buddhist scriptures were brought to Japan, it became popular to employ representations of Buddhas other than the historical one: Amida (Amitabha), Yakushi (Bhaisajyaguru), and Miroku (Maitreya). As faith in these Buddhas spread, temples came to attempt to depict in paintings and sculpture the heavenly dwelling places of such divinities. It is in fact a characteristic of Mahayana Buddhism to try to recreate the infinitely large worlds of which the individual great Buddhas are the centers. Ancient Buddhist monastery layouts, for example, are one way of representing those worlds. The area enclosed by the surrounding covered corridors, beginning at an inner gate, is the world of the Buddha. The Golden Hall (Kondo) is his residence (Fig. 3). Consequently, in the oldest temples, a huge altar called the Shumidan (Sumeru altar, named for the mountain believed to be the center of the Buddhist universe) fills virtually the entire interior of the Golden Hall, thus making it impossible to hold services in that place. To further heighten the sense of an ethereal dwelling, a nimbus rises behind the main image, and on it are depicted clouds, flying angels, and other Buddhas—all indicative of the splendors of the world of the Buddha represented in the main image.

Since the worlds of the Buddhas are thought to be infinitely large, the respective Buddhas who rule them are naturally also quite immense. For example, one of the sutras (sacred scriptures) describes the Buddha Amida as measuring to figures of truly astronomical range and employs such similes as "vast as the number of grains of sand along the shores of the Ganges." The figures themselves are staggering, but the meaning is clear: the Buddha is vast enough to cover the entire universe. It is scarcely surprising, then, that the temples of Mahayana Buddhism, seeking to convey such ideas of immensity, went in for enormous statues of the Buddhas. These statues, logically enough, were

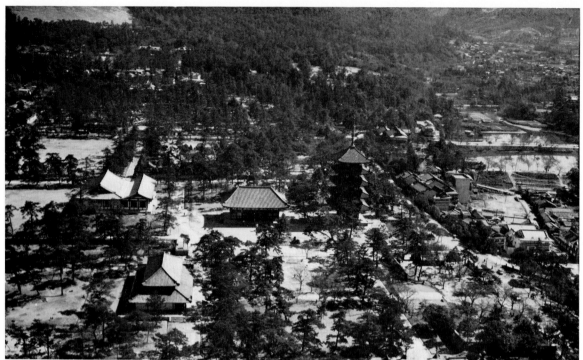

1. Kofuku-ji, Nara, viewed from the west. At center are the East Golden Hall and the five-storied pagoda; at lower left, the Central Golden Hall.

2. Detail view of two-storied pagoda, Kongobu-ji, Mount Koya, Wakayama Prefecture.

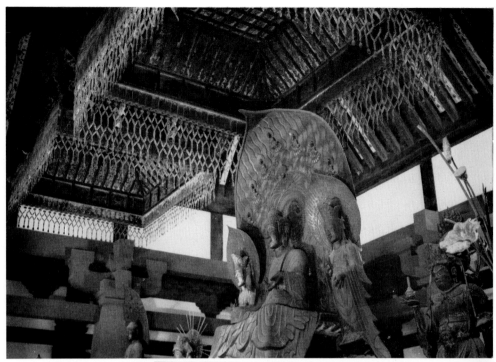

3. *Interior of Golden Hall, Horyu-ji, Nara. Eighth century.*

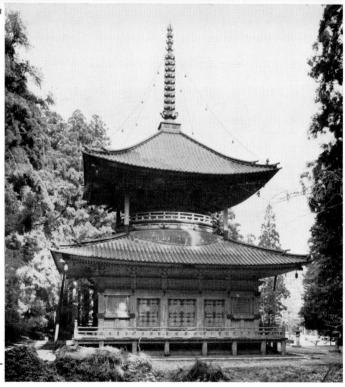

4. *West Pagoda, Kongobu-ji, Mount Koya, Waka-yama Prefecture. A reconstruction dating from 1835.*

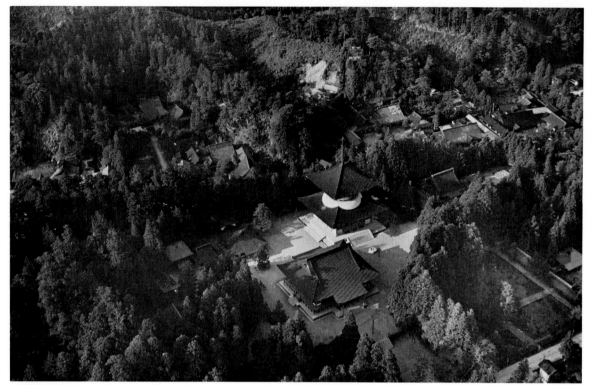

5. *Kongobu-ji, Mount Koya, Wakayama Prefecture, viewed from the southwest. At right of center is the two-storied pagoda, with the Lecture Hall (today called the Golden Hall) in front of it and the Mieido behind it at left. The smaller West Pagoda is in the stand of trees at lower left.*

called Great Buddhas (Daibutsu), and a comparatively large number of them were made for Japanese temples. The most famous is the Daibutsu at the Todai-ji, in Nara.

Needless to say, Mahayana Buddhism greatly venerated the concept of the world of the Buddha and taught its followers that in order to attain that blissful realm it behooved them to persevere in prescribed religious training. Still, the patent gap between the ideal world of the Buddha and the much less than ideal world of actuality needed in some way to be filled if the faithful were to remain faithful. The expedient method to achieve this end

was to make artistic representations of blessed realms: visual depictions that could be kept before the eyes of the people. Conservative Mahayana Buddhism, during its period of greatest influence in Japan, combined the art of primitive Buddhism, based on tales of the terrestrial life of the historical Buddha, with more sophisticated Mahayana art into what is called the "revealed teaching" (*kenkyo*), or Exoteric Buddhism, as opposed to the "concealed teaching" (*mikkyo*), or Esoteric Buddhism, which is the subject of the bulk of this book.

Kenkyo was carried on openly so as to be understandable to the intellectual powers of humankind.

6. *Buddhas of the Diamond World, West Pagoda, Kongobu-ji, Mount Koya, Wakayama Prefecture. Lacquer and gold leaf over* ▷ *wood; height, about 1 m. each. The statue of Dainichi Nyorai (center) dates from about 887; the other statues are nineteenth-century works. (See also Figure 39.)*

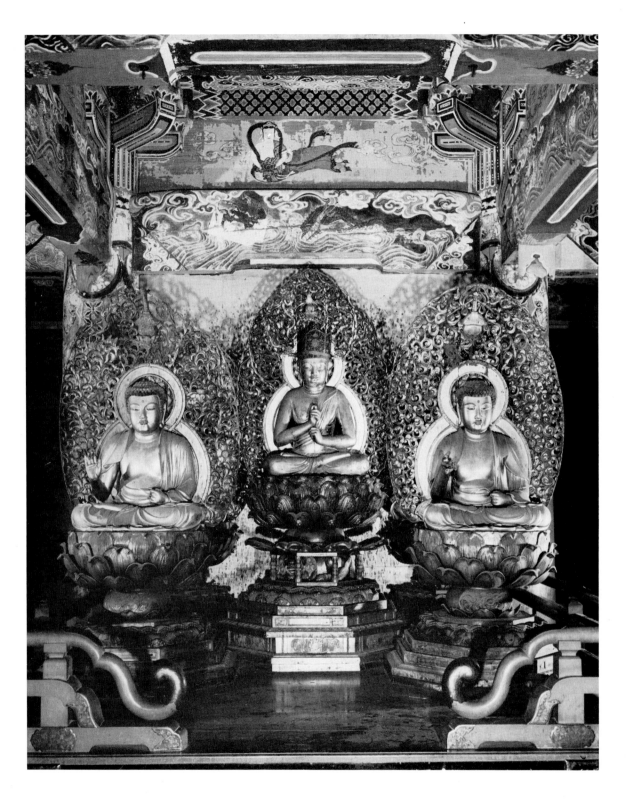

7. *Inner precinct of Golden Hall, Kanshin-ji, Osaka. About 1375. (See also Figure 10.)*

Mikkyo, or Esoteric Buddhism, on the other hand, insisted that the essence of Buddhism was never directly understandable to mankind. It therefore relied greatly on ritual and magical practices concealed from all but the initiate. Though this might suggest that the basis of Esoteric Buddhism was narrow, in fact its primary tenet was one of tremendously wide applicability. Esoteric Buddhism, contrary to the teachings of the older so-called revealed school, holds that man is capable of attaining Buddhahood on this earth. In order to do so, however, he must meditate in his heart on the images of certain Buddhas and perform certain rites. Both the forms of the images and those of the rites are strictly described and set forth in an extensive code of rules. And it is these rules that give characteristic shapes and attributes to the various arts and crafts associated with Esoteric Buddhism.

Since Esoteric teachings hold that the ideal realm of paradise (Mitsugon Kokudo or Mitsugon Jodo) is capable of being realized on earth, they seem more secular and practical than the older Exoteric conception of a remote and dreamy paradise attainable only after death. Nevertheless, visual representations of the Esoteric paradise take the form of the highly abstract and complicated mandala (in Japanese, *mandara*), a pictorial version of the cosmos in which all things emanate from the Great Sun Buddha Dainichi Nyorai (Vairocana). There are two mandala forms: the Mandala of the Diamond World (Kongokai), a symbolization of spiritual things that are as durable as the diamond, and the Mandala of the Womb World (Taizokai), a symbolization of the material universe. The two

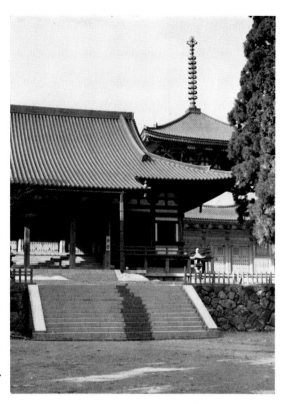

8. *Lecture Hall (Golden Hall) and two-storied pagoda, Kongobu-ji, Mount Koya, Wakayama Prefecture.*

are often combined in what is called the Mandala of the Two Worlds.

The hope of creating paradise on earth resulted in temple layouts that differ radically from those of earlier periods. The most representative product of this change is the temple Kongobu-ji on Mount Koya. Although much of the original architecture has been destroyed, the original general layout is still apparent. Just inside the inner gate is the Lecture Hall (today it is called the Golden Hall), and deep within the compound, placed one on the left and one on the right, are two pagodas (Fig. 5). At a glance this seems to be a reversal of the old plan of the kind found in many Nara temples: an inner gate, a pagoda, the Golden Hall, the Lecture Hall. But, in attempting to understand the plan of the Esoteric temple, it is necessary to bear several very

important points in mind. For example, in the older temples the pagoda was a reliquary enshrining some relic of the historical Buddha and thus, in a sense, representing that Buddha. But this is not true in Esoteric temples, where there are two pagodas that stand for the Diamond World and the Womb World and house statues of the Five Buddhas (the Five Dhyani Buddhas) of those two worlds (Figs. 4, 6, 39). In fact, based on the two sutras most important to the Shingon sect of Esoteric Buddhism—the *Dainichi-kyo* (Vairocana Sutra) and the *Kongocho-kyo* (Diamond Crown Sutra)—the pagodas and their contents symbolize the ideal of the mandalas and therefore serve a function similar to that of the Golden Hall in temples of revealed Buddhism.

Today not many temples preserve as much of the

original layout as is to be seen at the Kongobu-ji, although it is said that the Kongosammai-in, also on Mount Koya, and the Anjo-ji, in Kyoto, originally followed a similar plan. In the provinces, however, it was more common to build only one pagoda and to combine in it representations of both mandala worlds. Moreover, the pagoda was sometimes eliminated altogether, and a statue of Dainichi Nyorai, the central Buddha of Esoteric teaching, was made to do the services of the mandalas and was kept in the main temple hall.

The Lecture Hall of Esoteric Buddhism also departed from the standard plan. Instead of being a place for the reading and hearing of the sutras, it became the scene of the most important Esoteric rites. It was divided into inner and outer precincts by means of a lattice, and an image of a Buddha was enshrined in the innermost central part of the inner precinct. On the walls between the columns on either side of the image were the Diamond World and the Womb World mandalas. The oldest extant example of this type of layout is the Kanshin-ji, in Osaka (Figs. 7, 10). The former Lecture Hall of the Kongobu-ji (now the Golden Hall, as we have noted above) is based on a similar plan, but there is a wide space all the way around the inner and outer precincts.

The Kongobu-ji is the head temple of the Shingon Esoteric sect. The other most important Japanese Esoteric sect, Tendai, has as its head temple the Enryaku-ji, located just outside Kyoto on Mount Hiei. The Lecture Hall there, however, reveals another interesting architectural adaptation to the needs of Esoteric ritual. The building is in two precincts, inner and outer, but the stone-paved inner precinct is on a lower level than the outer one, which is floored with wood. The shrine housing the main image, located in the innermost section of the inner precinct, is raised so that its level corresponds with that of the floor of the outer precinct.

As already noted, the earlier schools of Buddhist teaching concentrated on the historical Buddha Shaka and, in their attempts to suggest the vastness of his being, frequently made immense statues of him. The central Buddha of the Esoteric sects is in fact Dainichi, the Great Sun Buddha, but greater faith and interest were directed toward many other associated deities than toward him. As a consequence, Esoteric Buddhism generally avoided large statues of one Buddha in favor of smaller ones of a wide range of other gods and holy beings. For example, an important sutra dealing with the Juichimen Kannon (Eleven-headed Kannon, or Ekadasamukha) tells of making a statue of this deity of good-quality sandalwood less than forty centimeters tall. There were two reasons for this preference for smaller statues. First, the Esoteric sects were more interested in the personalities and powers symbolized by various deities than in attempts to suggest immensity. Second, the necessity of producing many such statues and of finding space for a considerable number of them in each place of worship obviously limited the sizes of the individual figures.

During the flourishing period of Esoteric Buddhism, the number of deities to be represented grew by leaps and bounds. Furthermore, the rules for making and displaying the images became increasingly complex. In general, however, all these deities fall into one or the other of two classes: deities originating within the boundaries of the Buddhist faith and others borrowed from different faiths—Hinduism, for example—and incorporated into the Buddhist pantheon. Each god and divine being had his own personality and powers, but all of them offered certain benefits in this world to those who would believe.

9. Nyoirin Kannon, Golden Hall, Kanshin-ji, Osaka. Painted wood; height, 108.8 cm. About 836. (See also Figure 83.) ▷

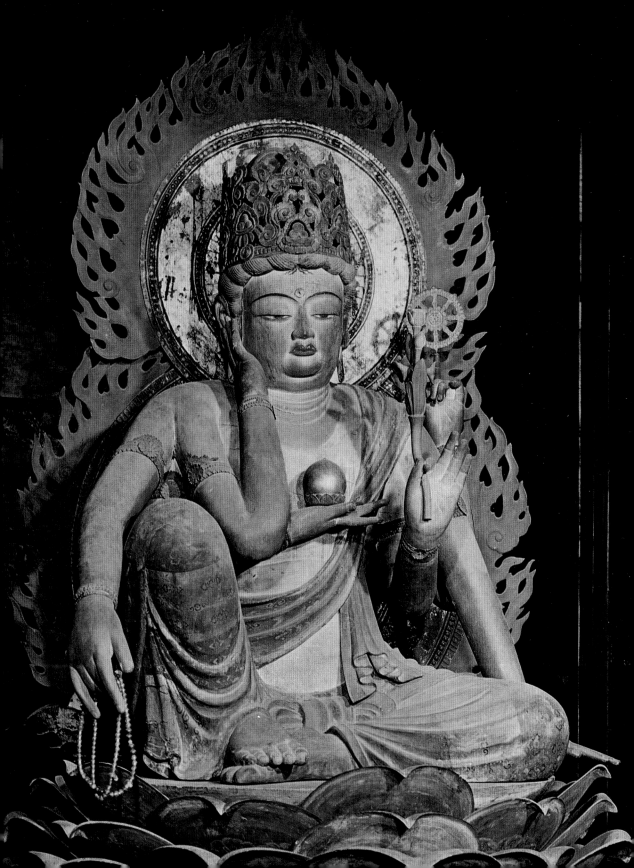

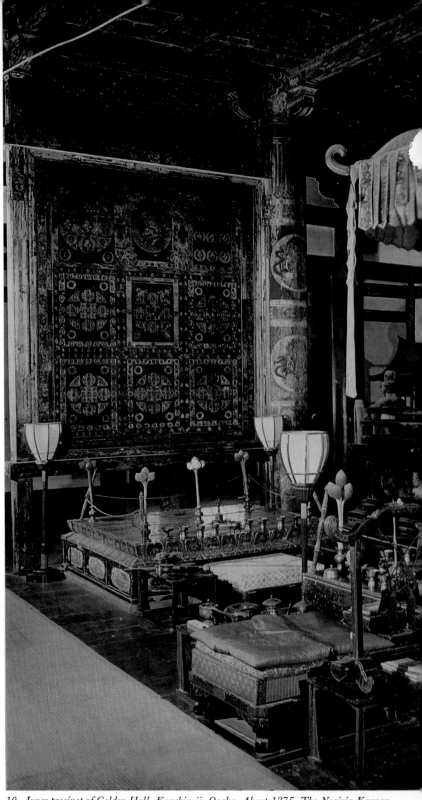

10. *Inner precinct of Golden Hall, Kanshin-ji, Osaka. About 1375. The Nyoirin Kannon (Figure 9) is concealed behind the doors at upper right. The Mandala of the Diamond World is at extreme left. (See also Figure 7.)*

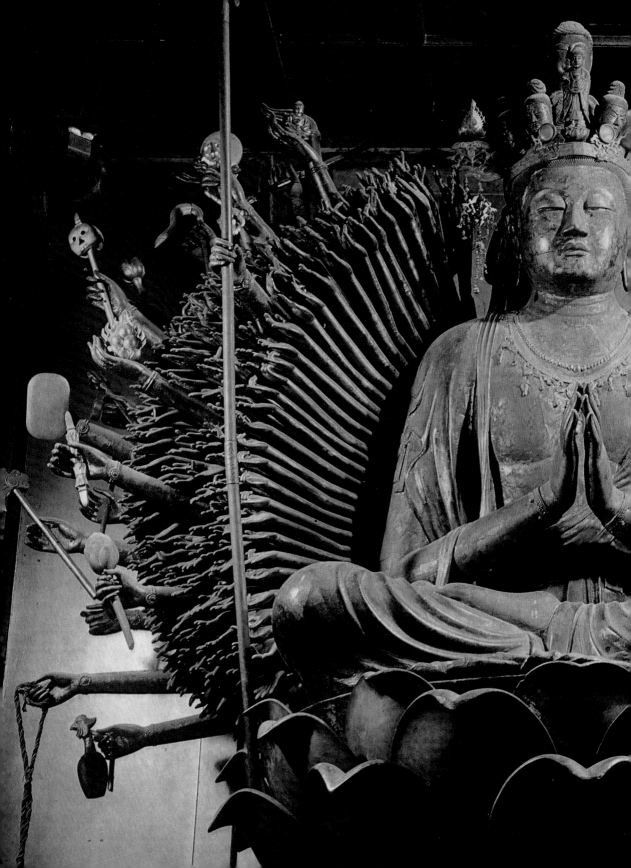

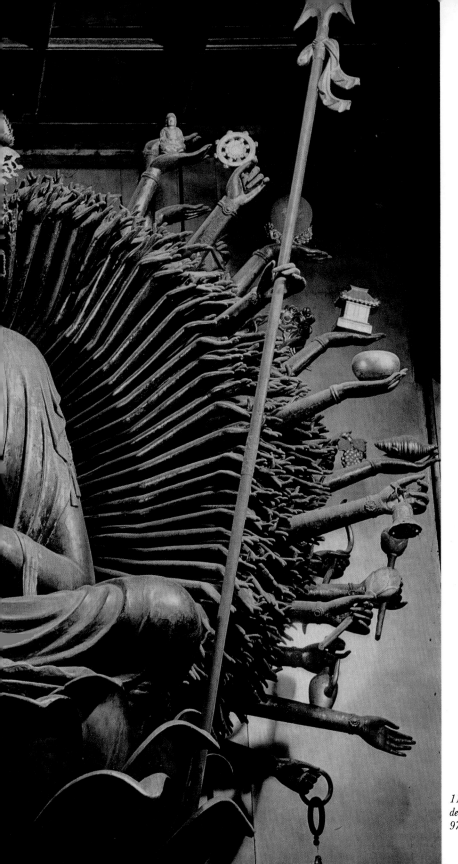

11. Thousand-armed Kannon, Fujii-dera, Osaka. Dry lacquer; height, 97.9 cm. Late eighth century.

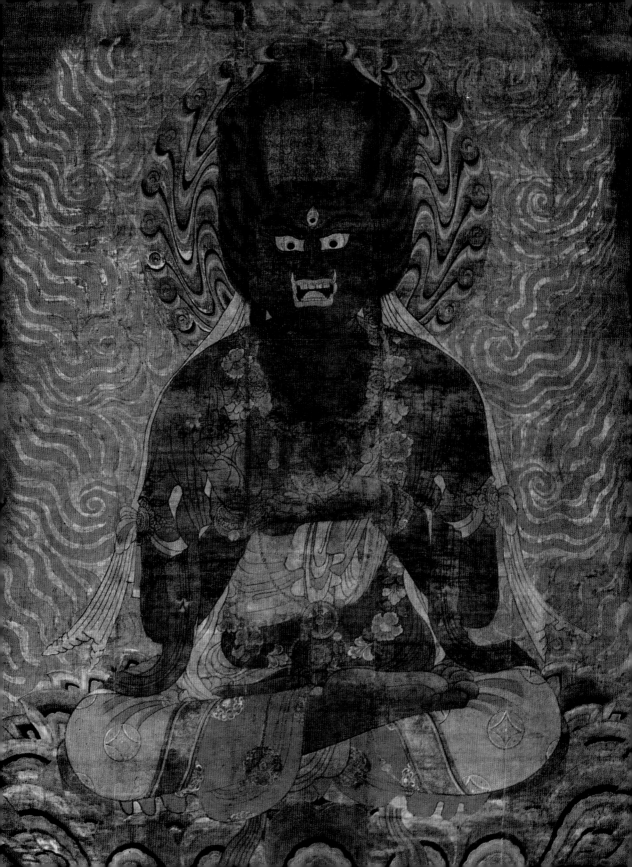

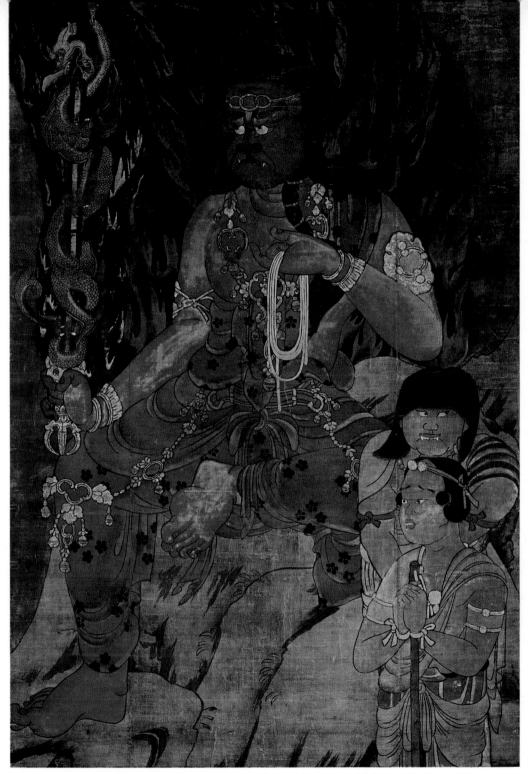

13. *Fudo Myo-o (the Red Fudo)* and doji *attendants, Myo-in, Mount Koya, Wakayama Prefecture. Colors on silk; height, 165 cm.; width, 95.8 cm. Ninth century.

12. *Kongoku Bosatsu, one of the Five Mighty Bodhisattvas, Yushi Hachimanko Juhakka-in, Mount Koya, Wakayama Prefecture. Colors on silk; height, 322.7 cm; width, 237.6 cm. Mid-ninth century.*

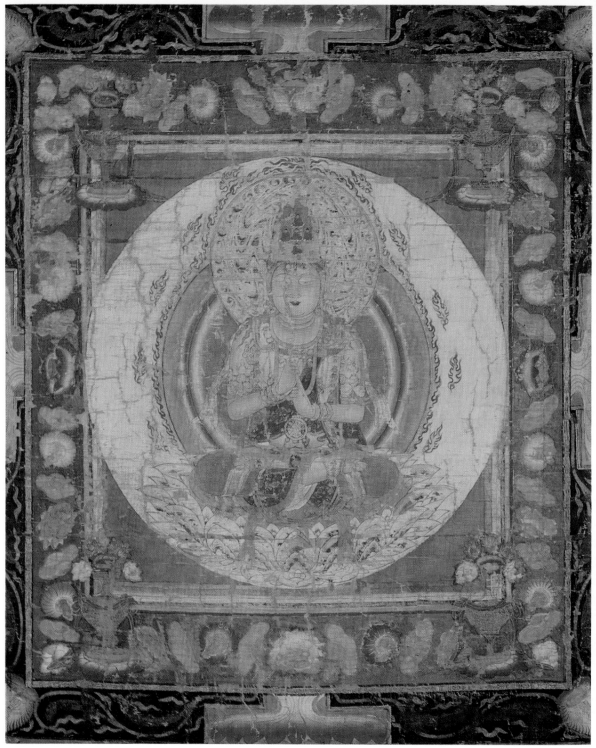

14. Dainichi Nyorai: detail from Diamond World section of Mandala of the Two Worlds, To-ji, Kyoto. Colors on silk; dimensions of entire mandala: height, 183.3 cm.; width, 154 cm. Late ninth century.

CHAPTER TWO

Esoteric Art
of the Ancient Period

MANY DEITIES FROM other religions incorporated as guardians into the Buddhist canon retained their original non-Buddhist—usually Sanskrit—names (in Japanese versions) with appellations attached to designate something about them or the roles they played. Examples of such appellations are Yakusha (Yaksa), Kongo (Vajra), and Ten, the last of which signifies a divine being. A large number of these deities never gained popularity in Japan, but those known as Ten did, even as early as the Nara period (646–794), before the full-scale establishment of true Esoteric sects. Perhaps the most popular of these are the Shitenno, or Four Celestial Guardians: Bishamon Ten (Vaisravana), also known as Tamon Ten; Jikoku Ten (Dhrtarastra); Komoku Ten (Virupaksa); and Zocho Ten (Virudhaka).

The Shitenno were so important to the great Asuka-period (552–646) prince and statesman Shotoku Taishi (573–621) that he had a temple, the Shitenno-ji, built in their honor. These deities, originally the Indian Four Lokala, who dwelt on Mount Sumeru, center of the Buddhist universe, and guarded the four cardinal points of the compass, became protectors of the treasure of the faith upon their introduction into Buddhism. Although in their early Indian forms they are weaponless, Buddhists in other regions clad them in armor and gave them the weapons used in those regions. It is

in their military guise that they are best known in Japan, but the styles of costume and the kinds of weapons vary. The oldest extant representations of the Shitenno in Japan are the ones preserved in the Golden Hall of the Horyu-ji, in Nara (Fig. 17). Though clad in armor, these statues wear crowns instead of helmets. Long sleeves hang at their sides, and the skirts of their costumes are gracefully pleated. They have a stern look of anger in their eyes, but they are generally more human in mood than other Buddhist statues of the period.

The next oldest Shitenno statues are those in the Golden Hall of the Taima-dera, in Nara (Fig. 16). These figures, less violently angry, are executed in a more realistic style. Though they too wear flowing garments under their armor, the faces differ entirely from those of the Horyu-ji statues in that they are decidedly neither Chinese nor Japanese in feature. In the later Nara period (eighth century) it became fashionable to depict the Shitenno with raging anger in their eyes and with very closely fitting armor. The prototype of the style, the statues at the Jikido (Refectory) of the Horyu-ji (Fig. 15), clearly influenced similar groups at the Hokkedo and the Kaidan-in of the great Nara temple Todai-ji. These styles, however, were abandoned in the last years of the Nara period, when a new kind of Shitenno posture, character-

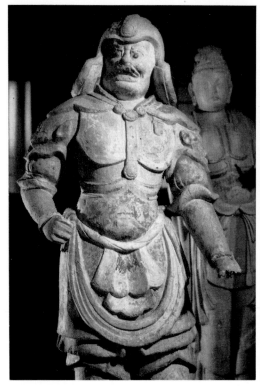

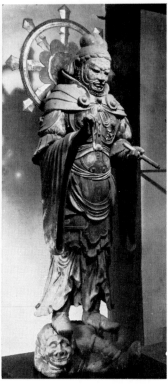

15 (left). Zocho Ten, one of of the Shitenno, or Four Celestial Guardians, Refectory, Horyu-ji, Nara. Painted clay; height, 102 cm. Seventh or eighth century.

16 (right). Komoku Ten, one of the Shitenno, or Four Celestial Guardians, Golden Hall, Taima-dera, Nara. Dry lacquer; height, 217 cm. Second half of seventh century.

17. Komoku Ten, one of the Shitenno, or Four Celestial Guardians, Golden Hall, Horyu-ji, Nara. Painted wood; height of entire statue, 132.7 cm. Mid-seventh century.

ized by sleeves rolled up over the upper part of the arms, came into fashion and remained so throughout the Heian period (794–1185).

Two other important guardian deities of the Ten category are Taishaku Ten (Indra) and Bon Ten (Brahma), both borrowed from Hinduism. Bon Ten, ruler of the world of the living, and Taishaku Ten, lord of a paradise on the summit of Mount Sumeru, are superiors of the Shitenno who are said to have heard and believed the teachings of Shaka and then to have sworn to defend the Buddhist faith. They are almost always found as a pair in the Golden Halls of Nara-period temples. Although it is uncertain when statues of the two began to be produced in Japan, since the oldest extant ones are the clay figures in the Refectory of the Horyu-ji (Fig. 20), at the latest they were being made during the Wado era (708–15). Other famous examples include the Taishaku Ten and Bon Ten statues in the Hokkedo of the Todai-ji and a similar pair in

the Refectory of the Toshodai-ji, another of the great Nara temples. All of these figures have a gentleness of facial expression reminiscent of the countenances of Bodhisattva statues, but, as guardian deities, they wear a kind of abbreviated armor under their flowing outer garments (Fig. 19). This combination of calm and military symbol indicates that as divinities Taishaku Ten and Bon Ten stand a grade or so higher than the Shitenno, who are, as we have noted, their hierarchical inferiors. The form just described is the one that the statues assumed in the Nara period, but their appearance changed after the great priest Kukai (Kobo Daishi) introduced true Esoteric sects into Japan during the Heian period.

The statues of Bon Ten and Taishaku Ten at the Kyoto temple To-ji (or Kyo-o-gokoku-ji, as it is more properly but less familiarly called) differ from the Nara-period statues in several important respects. First, whereas the older statues had only one

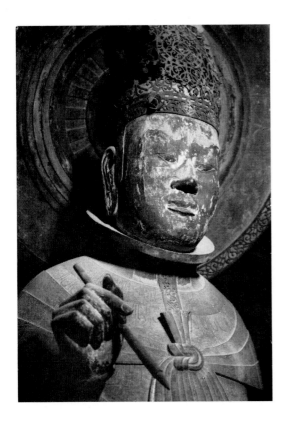

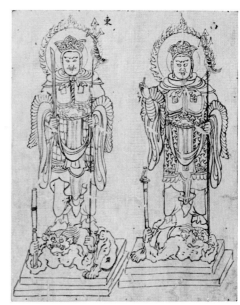

18. *Jikoku Ten (left) and Komoku Ten (right), two of the Shitenno, or Four Celestial Guardians, in the Shitenno-ji, Osaka: one of a set of drawings dealing with Buddhist iconography, Ninna-ji, Kyoto. Ink on paper. Second half of twelfth century.*

head and two arms, the Bon Ten at the To-ji has not only four arms but also four heads (Figs. 82, 112). Second, the older statues are standing figures, while the Heian-period ones are mounted: Taishaku Ten on a wonderful white elephant (Fig. 79) and Bon Ten on four geese (Fig. 112). Obviously the Indian element is pronounced in the new forms introduced by Kukai. After the Heian period, however, the practice of placing representations of these two deities in Golden Halls fell out of use. Consequently, not only did the Indian style die out, but also nothing new (or old) came in to take its place.

This fate did not overtake statues of the Ni-o, which were produced from the Nara period until much later times (Fig. 34). These two mighty kings are most famous as guardians placed to the right and left of gateways to Buddhist temples. They are collectively called the Kongo Rikishi (Vajrapani) and are popularly known as the Ni-o (Benevolent Kings), but they actually have separate names: the

one on the left, Misshaku Kongo; the one on the right, Naraen Kongo. Though in their Hindu forms statues of the two predate the Christian era, the oldest in Japan is a bronze relief plaque at the Hasedera (Nara Prefecture) which was made in 686 (Fig. 22). The oldest free-standing statues are the large clay Ni-o in the inner gate of the Horyu-ji (Fig. 23), which date from the early years of the eighth century.

The appellation Kongo derives from the word *kongosho*, the Japanese name for the *vajra*, the thunderbolt or dagger-shaped weapon which, when possessed by Taishaku Ten in his abode atop Mount Sumeru, was used to accomplish the miraculous and convenient feat of changing the weather. When Taishaku Ten and Bon Ten were won over to the Buddhist faith, the *vajra* came along with them. The weapon then became a symbol of great power in averting and conquering evil. Usually one of a pair of Ni-o is shown brandishing the *vajra*,

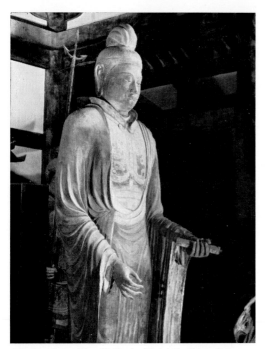

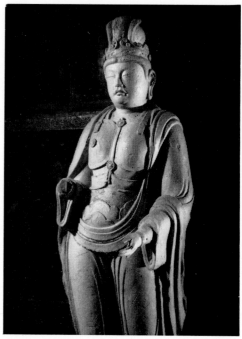

19. *Taishaku Ten, Hokkedo, Todai-ji, Nara. Colors on dry lacquer; height, 404.6 cm. Mid-eighth century.*

20. *Bon Ten, Refectory, Horyu-ji, Nara. Painted clay; height, 108.5 cm. Seventh or eighth century.*

but sometimes the sheer muscular force and the aggressive stance of the statue are used to suggest power, and the weapon itself is not shown.

The general appearance of these statues is one of flaming anger and tremendous strength. They are usually naked to the waist, and the impression of power conveyed by the rippling muscles and tensed veins of their bodies is intended to deter the would-be evildoer from knavery. Though they appear furious and malevolent, they are in fact benign. Their rage is directed against any and all who would bring harm to Buddhism. Oddly enough, in the light of the virility and masculinity of their general appearance, their hair is frequently done up in graceful knots and held in place with ribbons or ornaments. This is the most widely accepted way of depicting the Ni-o, but there is an interesting exception at the Hokkedo of the Todai-ji. This statue is clothed in armor and apparently once held a short sword. His hair stands up straight in an

expression of extreme rage (Fig. 21). There are no similar statues in Japan.

The Hokkedo of the Todai-ji also has an interesting statue of Shukongojin (Vajradhara), a guardian deity worshiped by a special sect in the Nara period but never widely popular. Here the god wears armor and carries an elongated version of the *vajra* (Fig. 26). Existing records tell of the worship of this deity, but no exact information on the canonical sources for such worship is available. A copy of the statue, made during the Kamakura period (1185–1336) by the famous sculptor Kaikei, is kept at the Kongo-in, in Kyoto.

Among the sutras most venerated during the Nara period was the *Konkomyo-kyo*, the *Sutra of the Golden Light*. A record at the Todai-ji proclaims that the temple is dedicated to the Four Celestial Guardians—that is, the Shitenno—of this sutra and thereby reveals both the importance of that scripture and its nature as the source of much of the

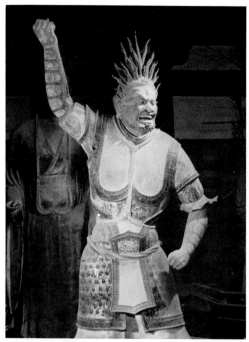

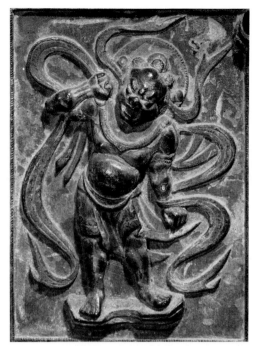

21. Ni-o (temple guardian), Hokkedo, Todai-ji, Nara. Colors on dry lacquer; height, 326 cm. Second half of eighth century.

22. Ni-o (temple guardian), Hase-dera, Nara. Bronze. Dated 686.

worship of the Shitenno. In addition, however, the sutra prescribes faith in certain goddesses, and, in keeping with that precept, statues of the divine ladies were frequently made during the Nara period. Today we have representations of such divinities as Kissho Ten (Sridevi) and Benzai Ten (Sarasvati) surviving from that age.

The Buddha Shaka, the first to attain enlightenment in our world, was male, but later, as methods of spreading his teachings altered, it became customary, in the many lands to which the religion traveled, to represent him according to a set of thirty-two characteristic features and eighty favorable signs and to de-emphasize indications of sex. The introduction of female divinities into Buddhist worship is probably the result of Hindu influence. Their prototypes may be seen in the reliefs of voluptuous goddesses on the ornamental fences surrounding ancient Hindu temples. In the sixth and seventh centuries it became customary to place statues of goddesses beside figures of Shaka and Kannon. The first such goddess figures made in Japan date from the Nara period.

Since until this time statues of female divinities had played no role in Japanese Buddhist worship, the dazzling splendor of Kissho Ten, when she finally came to be adored independent of other deities, doubtless aroused more than ordinary interest on the part of the priests. Needless to say, the popularity of Kissho Ten worship spread quickly. There is even an old story about a man who fell in love with a picture of this splendid beauty. As the goddess of good fortune, Kissho Ten is said by some authorities to have twelve names, whereas others burden her with the cumbersome load of one hundred and eight. She was the consort of Bishamon Ten (Vaisravana), and their joint worship was generally popular during the Heian period. The most notable representations of Kissho Ten dating from the Nara period are the exquisite

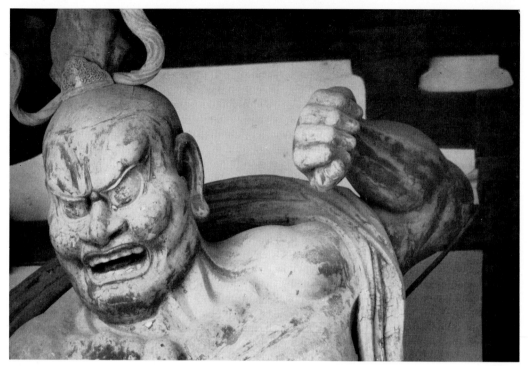

23. Ni-o (temple guardian), inner gate, Horyu-ji, Nara. Painted clay; height of entire statue, 330 cm. Dated 711.

painting at the Yakushi-ji (Fig. 36) and the clay statues at the Refectory of the Horyu-ji (Fig. 24) and at the Hokkedo of the Todai-ji (Fig. 43)—all in Nara.

The other most widely revered goddess of the period was Benzai Ten (Sarasvati), who in Hindu theology was the deity of a river bearing her name. Because of the destruction wrought by the river in flood time, she was associated with the violence of the natural elements and sometimes with warfare. On the other hand, because of the melodious murmurings of the river in its more placid moods, she also came to be worshiped as a goddess of music. A famous statue of Benzai Ten at the Hokkedo of the Todai-ji shows her in Esoteric form with eight arms which once held a bow, an arrow, a sword, a spear, an ax, a lasso, a *vajra*, and a wheel of the law (Fig. 44). The ravages of time make it impossible to reconstruct mentally the lost beauty of this statue, but a Kamakura-period painting of Benzai Ten at

the Tokyo University of Arts clearly shows the attributes held in the eight arms (Fig. 37).

Worship of the eight-armed Benzai Ten began in Japan during the Nara period, from which the above-noted statue dates. How popular the deity was during the succeeding Heian period is a matter of conjecture, but the cult revived in the late Kamakura period and became popular once again in the Muromachi period (1336–1568). A number of representations of the eight-armed Benzai Ten remain from those times. In her gentler manifestation as goddess of music, Benzai Ten was sometimes portrayed naked and usually holding a lute, as in a statue from the Kamakura period (Fig. 25).

Documents of great antiquity lead one to suppose that several other feminine deities achieved popularity in early Japanese Buddhism. One of the most important of these was Kishimojin, a form of the Hindu goddess Hariti, for whom there were many shrines and altars in Japan. The representa-

tion of her in the lower-left corner of the above-mentioned Kamakura painting of Benzai Ten (Fig. 37) shows her holding a pomegranate (her special symbol) and with children on her knees. This painting is a reproduction of an earlier work painted on the wall of a shrine dedicated to Kissho Ten.

Perhaps no Buddhist deity, short of the Buddhas themselves, ever attained the breadth and depth of popularity of the Bodhisattva Kannon, known in Sanskrit as Avalokitesvara and in Chinese as Kuan-yin. As a Bodhisattva, Kannon is usually ornamented with jewels and a diadem in which, in later periods, it became customary to enshrine a small image of Amida Nyorai, the parent Buddha of Kannon. So general is this practice that when identification of statues becomes difficult, as it frequently does, the presence of this small statue in the diadem always indicates that the deity represented is Kannon. In very early representations of Kannon, however, this small statue is sometimes omitted, as in the case of the famous Kudara Kannon at the Horyu-ji (Fig. 47). The earliest representation of Kannon in Japan to show the figure of Amida in the crown is a small gilt-bronze statue owned by the imperial household and displayed at the Tokyo National Museum (Fig. 48). It is dated 651.

The deity Kannon, one of the earliest Bodhisattvas mentioned in the Buddhist scriptures, has both tantric (Esoteric) and nontantric forms. Already known in the second century A.D., he is mentioned in the *Amida-kyo* (Amitabha Sutra) and in the *Hoke-kyo* (Lotus Sutra). As a deity who confers actual benefits on mankind in this world, Kannon is associated with the Vedic god Rudra, but the Kannon described in the *Darani Zoshu*, the Japanese version of a sixth-century Chinese translation of a collection of mystical prayers, seems to represent a synthesis of the attributes of several Hindu divinities. Kannon was the first Bodhisattva to assume many-headed, many-armed forms and thus influenced later representations of other Bodhisattvas. It is not clear when the first statues and paintings of Kannon were made in Japan, but it is certain that they were in production by the seventh century, since the small gilt-bronze Kannon mentioned above is definitely identifiable by the presence of the Amida

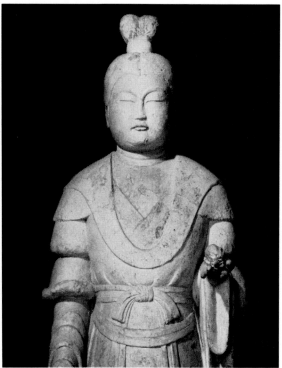

24. *Kissho Ten, Refectory, Horyu-ji, Nara. Clay; height of entire statue, 175.7 cm. Eighth century.*

image in its crown. Numerous other statues displaying similarities to Kannon were made during the early period of Buddhist development in Japan, and many authorities believe that some of them may be representations of Kannon. The previously noted Kudara Kannon is a case in point.

There is no clear documentation on the extent of Kannon worship in the early Nara period, but it seems likely that it was instituted and attained a degree of popularity soon after the introduction of Buddhism itself, which is traditionally assigned the date of 552. The eighth-century Japanese chronicle *Nihon Shoki* mentions the divinity in recording the reign of Emperor Temmu in the seventh century, thereby suggesting that even at this early stage the foundation of Kannon's great influence and popularity had already been laid. Throughout the growth and spread of faith in Kannon, statues and paintings of the deity took many forms.

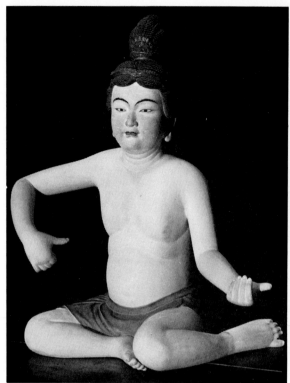

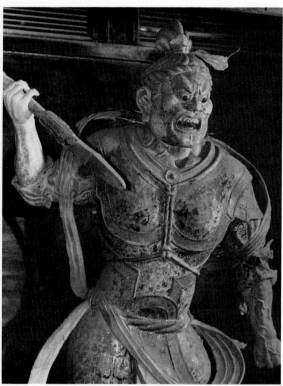

25. *Benzai Ten, Tsurugaoka Hachiman-gu, Kamakura, Kanagawa Prefecture. Painted wood; height, 96 cm. Dated 1266.*

26. *Shukongojin (guardian deity), Hokkedo, Todai-ji, Nara. Painted clay; height of entire statue, 167.5 cm. About 733.*

One of the most important of the early forms is the Eleven-headed Kannon (Juichimen Kannon), which symbolizes the all-seeing capability of the Bodhisattva. The Eleven-headed Kannon was the first tantric form of the divinity to be produced in Japan, and important examples of Nara-period representations in this form survive in the gilt-bronze statue excavated at Nachi and now in the Tokyo National Museum (Fig. 46); the now badly damaged murals in the Golden Hall of the Horyu-i (Fig. 45); and the dry-lacquer statues at the Shorin-ji (Fig. 52), the Kannon-ji (Fig. 29), and the Mie-dera (Fig. 51). In addition, documents from the period mention many other representations—an indication that the worship of this Bodhisattva was widespread among the Japanese at an early date.

The legend explaining the eleven heads relates that at one time Kannon, a divinity of all-embracing mercy and compassion, descended to earth to convert wicked people and lead them to the paradise of his spiritual father Amida Buddha. He was successful in his undertaking, but upon returning to earth he despaired because he saw that for every person he had saved there were still many other wicked ones. In the excess of his grief, his head split into ten fragments, whereupon Amida formed each fragment into a new head, placed all the heads on top of Kannon's body, and at the pinnacle added a representation of his own head. Thus Kannon became endowed with many eyes to observe the troubles of the world and many brains to contemplate ways of alleviating them.

The style and arrangement of the heads is not

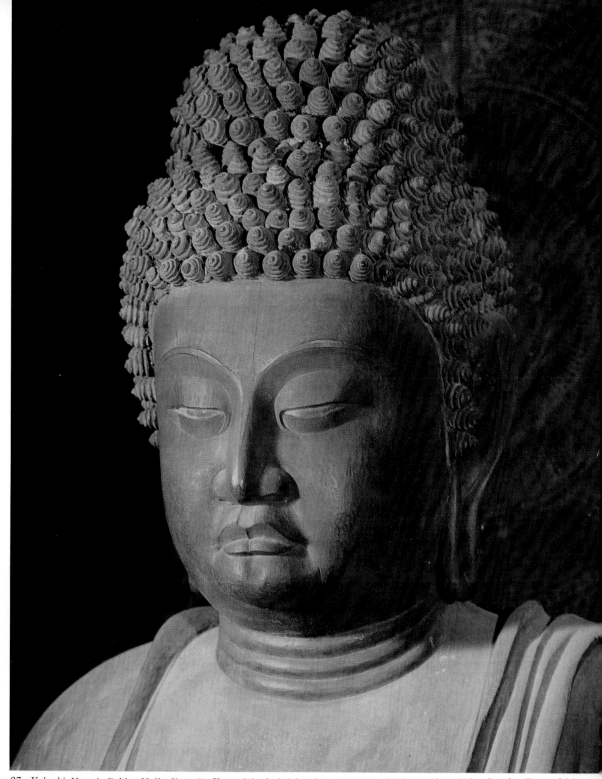

27. *Yakushi Nyorai, Golden Hall, Jingo-ji, Kyoto. Wood; height of entire statue, 170.3 cm. About 802. (See also Figure 84.)*

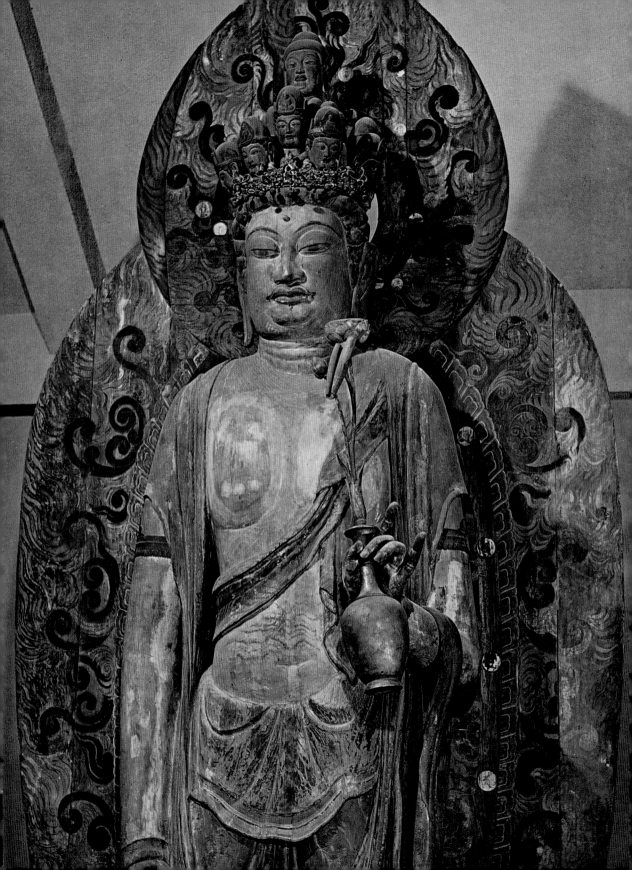

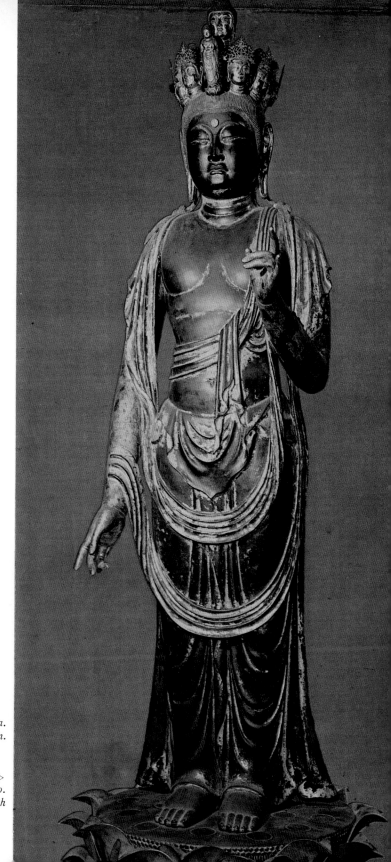

28. *Eleven-headed Kannon, Horin-ji, Nara.*
Painted wood; height of entire statue, 358 cm.
Ninth century.

▷

29. *Eleven-headed Kannon, Kannon-ji, Kyoto.*
Wood and dry lacquer; height, 172.7 cm. Eighth
century.

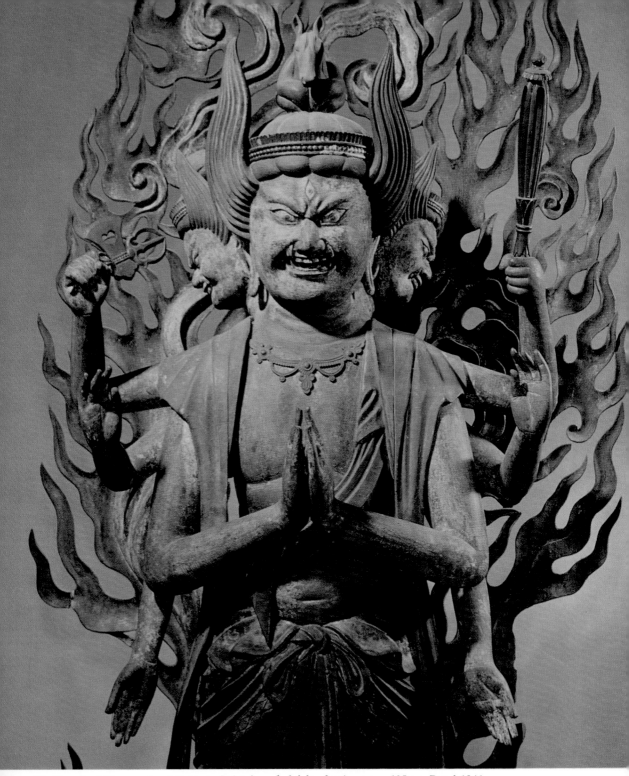

30. Horse-head Kannon, Joruri-ji, Kyoto. Painted wood; height of entire statue, 105 cm. Dated 1241.

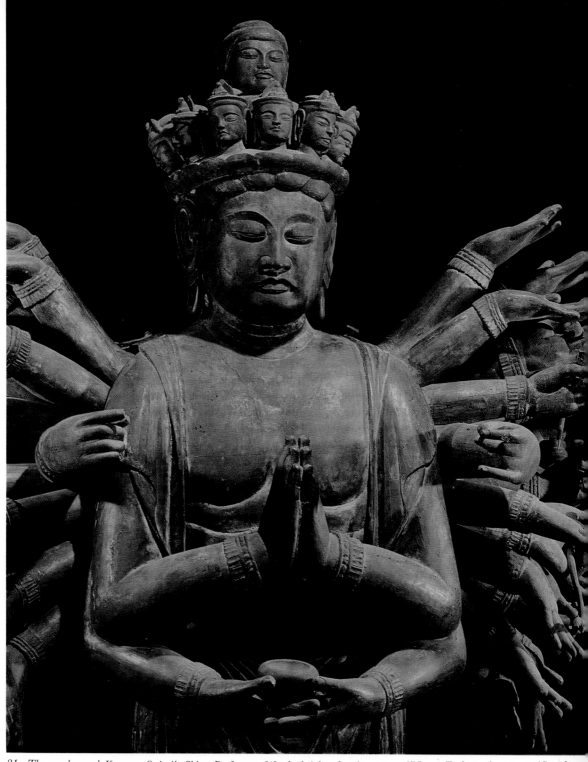

31. *Thousand-armed Kannon, Onjo-ji, Shiga Prefecture. Wood; height of entire statue, 175 cm. Early tenth century. (See also Figure 91.)*

◁

32. *Jizo Bosatsu, guardian deity of children, Lecture Hall, Koryu-ji, Kyoto. Wood; height, 109.7 cm. Dated 868.*

▷

33. *Nyoirin Kannon. Oka-dera, Nara. Painted clay; height of entire statue, 390 cm. Ninth century*

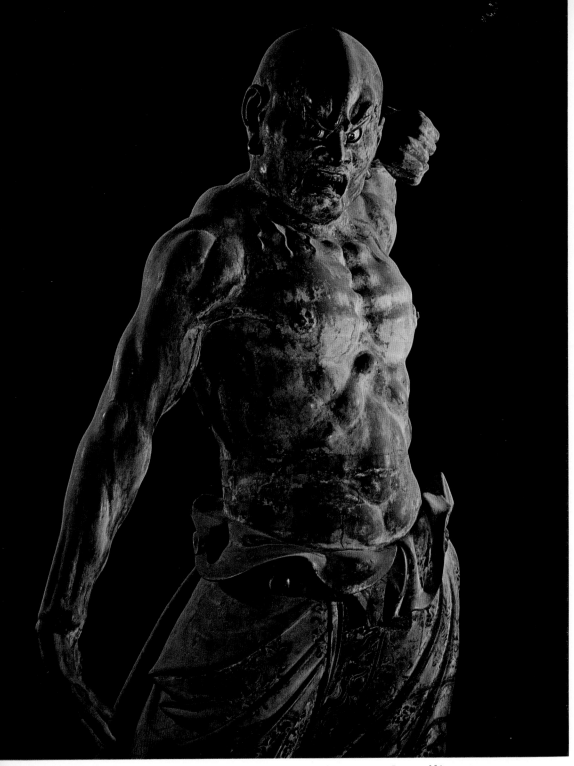

34. *Ni-o (temple guardian), Kofuku-ji, Nara. Painted wood; height, 161.5 cm. Late twelfth century.*

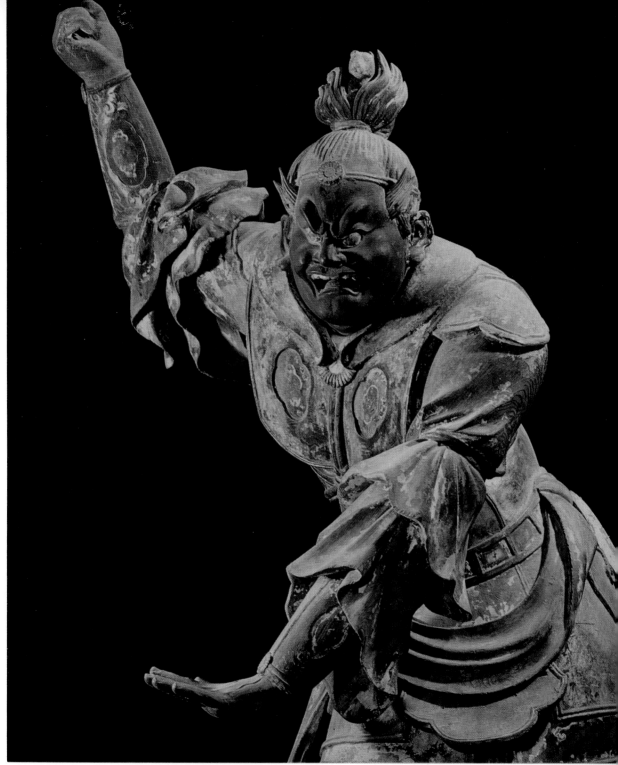

35. *Basara Taisho, one of the Twelve Godly Generals, Kofuku-ji, Nara. Painted wood; height, 120 cm. Dated 1207.*

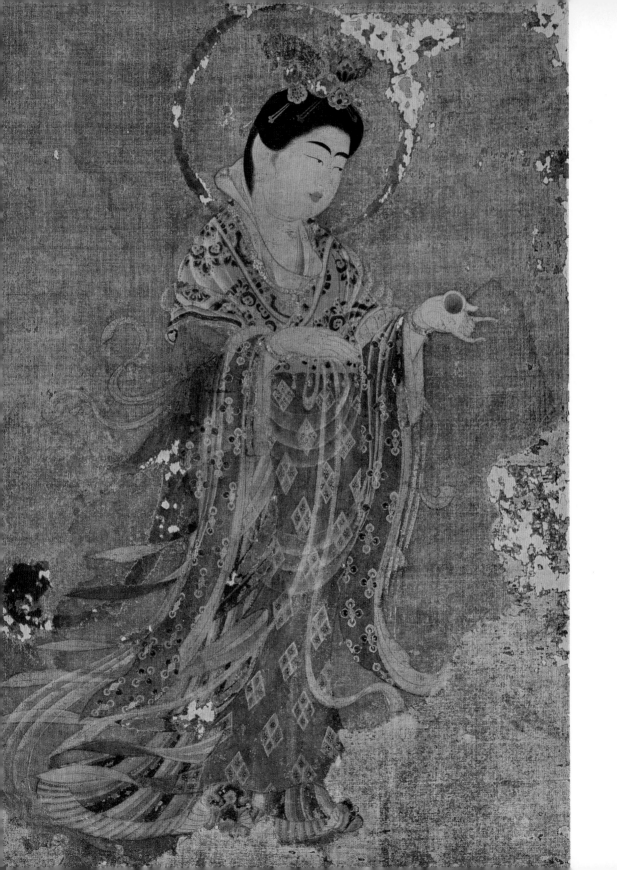

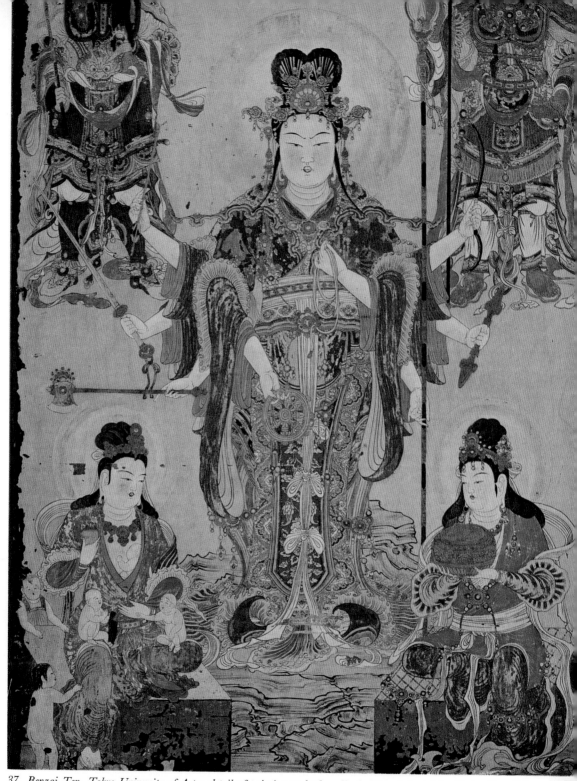

37. *Benzai Ten, Tokyo University of Arts: detail of painting on back wall of shrine dedicated to Kissho Ten. Colors on wood; dimensions of entire painting: height, 102 cm.; width, 62.9 cm. Dated 1212.*

◁ 36. *Kissho Ten, Yakushi-ji, Nara. Colors on linen; height, 53.3 cm.; width, 32 cm. Second half of eighth century.*

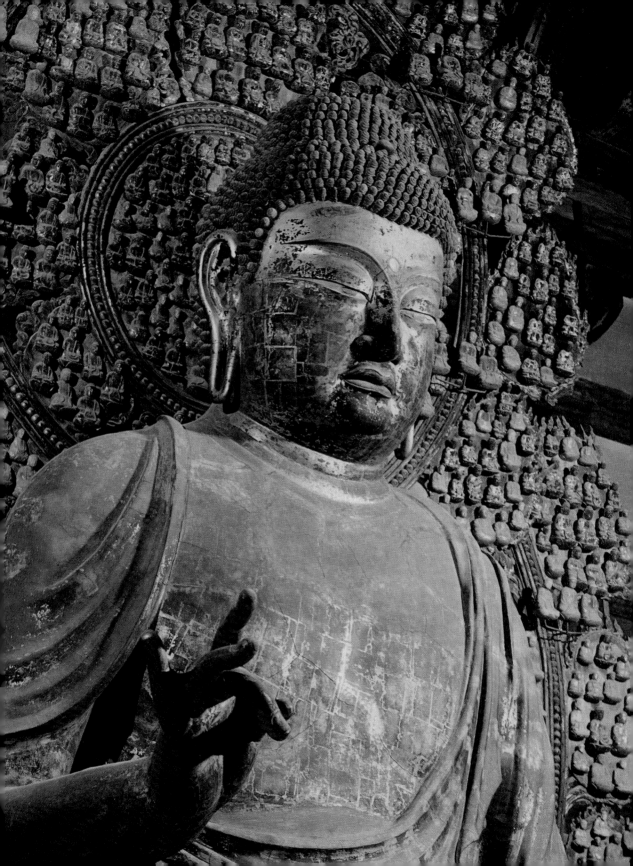

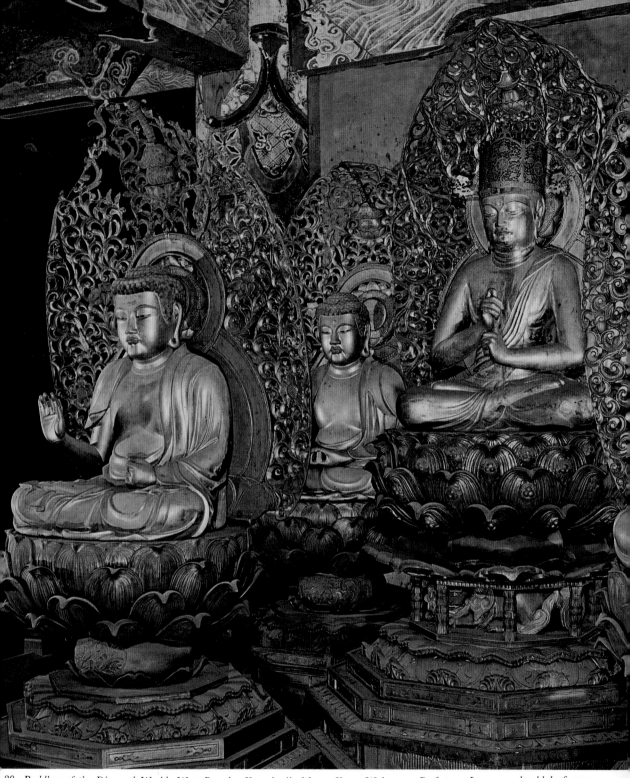

39. *Buddhas of the Diamond World, West Pagoda, Kongobu-ji, Mount Koya, Wakayama Prefecture. Lacquer and gold leaf over wood; height, about 1 m. each. The statue of Dainichi Nyorai (right) dates from about 887; the other statues are nineteenth-century works. (See also Figure 6.)*

38. *Rushana Buddha (Vairocana), Golden Hall, Toshodai-ji, Nara. Dry lacquer; height of entire statue, 303 cm. About 759. (See also Figure 57.)*

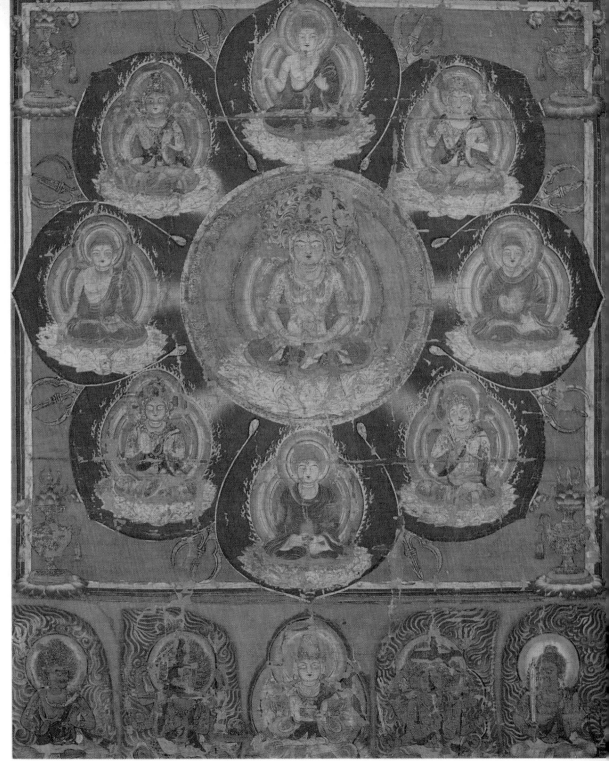

41. Dainichi Nyorai (center) and attendant deities on eight-petaled lotus: detail from Womb World section of Mandala of the Two Worlds, To-ji, Kyoto. Colors on silk; dimensions of entire mandala: height, 183.3 cm.; width, 154 cm. Late ninth century.

40. Taishaku Ten and attendant deities: detail from Taishaku Ten Mandala, Muro-ji, Nara Prefecture. Colors on wood; dimensions of entire mandala: height, 384 cm.; width, 192 cm. Ninth century.

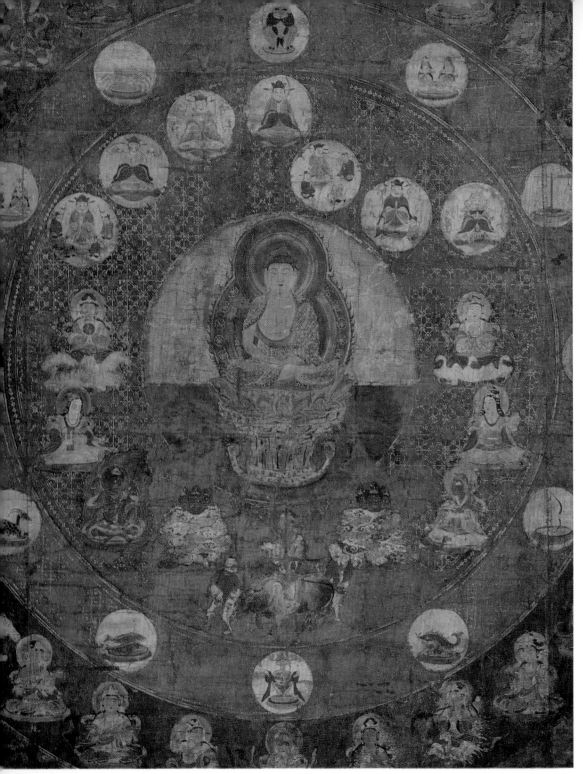

42. *Detail from Star Mandala, Horyu-ji, Nara. Colors on silk; dimensions of entire mandala: height, 118 cm.; width, 84 cm. Twelfth century.*

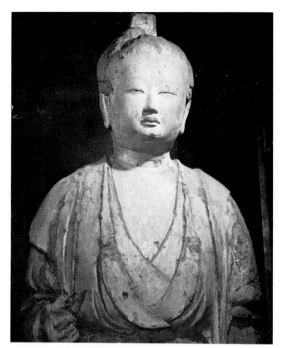

43. *Kissho Ten, Hokkedo, Todai-ji, Nara. Clay; height of entire statue, 218.8 cm. Second half of eighth century.*

consistent in all versions. The statue from the Nachi excavations, which has some supplementary heads with slightly larger eyes distributed among the others, is an early style unusual in Japan. The placement of two small heads at the ears of the main head and the arrangement of the remaining heads on its top is basically an Indian style that was not often employed during the Asuka and Nara periods in Japan, although the Horyu-ji murals include an example. After the full-scale institution of Esoteric sects during the Heian period, the style became more widespread and, like much Esoteric Buddhist art of the age, is even more markedly Indian in feeling. The statue at the Kogen-ji, in Shiga Prefecture, is a good example (Figs. 49, 56, 73). The classic arrangement of the heads in Japan places the Amida head in the center at the top, surrounded by two tiers of other heads.

Not only is the placement of the heads subject to variation, but also their number varies. Some au-

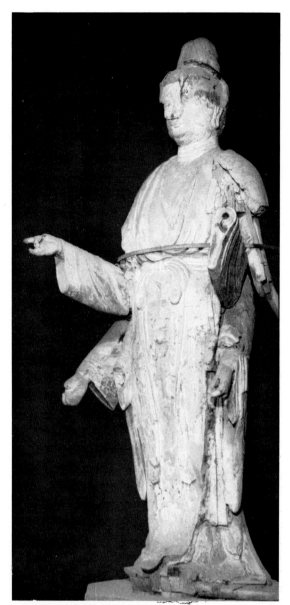

44. *Benzai Ten, Hokkedo, Todai-ji, Nara. Clay; height, 218.8 cm. Second half of eighth century.*

thorities hold that eleven, including the main head, is correct, while others contend that that statue must have a total of twelve heads. Apparently a difficulty even in T'ang-dynasty China, this ques-

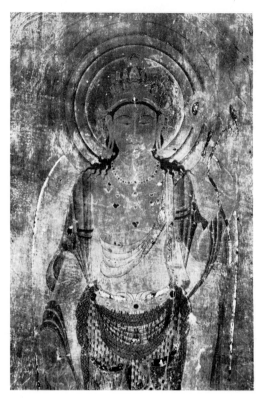

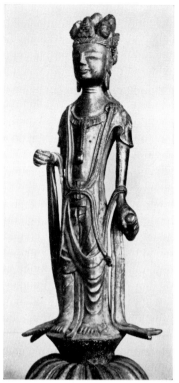

45 (left). Eleven-headed Kannon, formerly in Golden Hall, Horyu-ji, Nara; destroyed by fire in 1949. Colors on white clay wall; dimensions of entire painting: height, 333 cm.; width, 150 cm. Early eighth century.

46 (right). Eleven-headed Kannon, Tokyo National Museum. Gilt bronze; height, 31.5 cm. Late seventh or early eighth century.

tion was resolved by the Japanese priest Esho (650–714), who proclaimed the correct number to be twelve—that is, the main head plus eleven. Regulations governing these matters say that the three front faces should be the tranquil ones of Bodhisattvas, the three on the left should glare angrily, the three on the right should resemble Bodhisattvas but with protruding tusks, and the one at the back should laugh loudly and malevolently. The head at the pinnacle, of course, is that of Amida Buddha. In addition, however, these regulations state that all the heads should be of natural size, like the three heads of the statue of Ashura (Asura) at the Kofuku-ji, in Nara (Fig. 50). Indeed, a late-Heian-period picture at the Ninna-ji, in Kyoto, shows how the effect can be achieved in line drawing (Fig. 55), but the feat is far more troublesome in sculpture. Once again, however, Esho unraveled the difficulties by stating that equality of size in all the heads

was unimportant, since the heads were only symbols of the powers of Kannon. Acting on this precept, most Japanese sculptors have depicted the deity with one large and eleven small heads.

The Eleven-headed Kannon usually holds a vase with a lotus bud in his left hand. His right hand makes the gesture (*mudra*) of charity. His bare chest and arms are frequently adorned with jewels. At a later stage he was sometimes shown with four arms, but most of the earlier versions have only two.

Another form of Kannon to gain early popularity in Japan was the Fukukenjaku (or Fukukensaku) Kannon (Amoghapasa), many sutras about whom were translated from Sanskrit into Chinese in only a few decades after the end of the sixth century. Although ancient records show that several statues of Fukukenjaku Kannon were made in the late Nara period, the only one surviving from those times is the main image in the Hokkedo of the

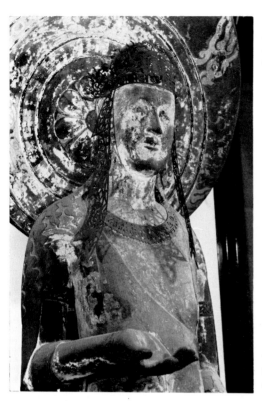

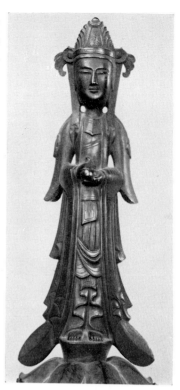

47 (left). Kudara Kannon, Horyu-ji, Nara. Painted wood; height of entire statue, 209.2 cm. First half of seventh century.

48 (right). Kannon, Tokyo National Museum. Gilt bronze; height, 23.3 cm. Dated 651.

Todai-ji (Fig. 54). The sutras are not clear concerning the proper number of arms and heads for representations of this Kannon. In Japan, where niceties of detail were sometimes overlooked, examples range from images with one head and two arms, one head and four arms, three heads and four, six, or ten arms to images with as many as eleven heads and twelve arms. But the general form called for one head and eight arms, as is clear from the Hokkedo statue noted above. This statue, however, has three eyes, a peculiarity that began to appear in Bodhisattva sculpture around the middle of the late Nara period—that is, during the second half of the eighth century. The use of many arms in Japanese Buddhist sculpture has the precedent of the Ashura statue in the pagoda of the Horyu-ji and of the statue of the same divinity at the Kofuku-ji (Fig. 50). These two images have long, gracefully abstract arms that trace moving lines in the air. By contrast, the arms of the Fukukenjaku Kannon at the Todai-ji Hokkedo are clearly more realistic and are designed to hold the several symbols of the powers of the divinity. Such popularity as this Kannon achieved in Japan doubtless derived from his avowed aim of saving all mankind. On the other hand, the practice of depicting the Fukukenjaku Kannon with a deerskin over one shoulder led to an association with the Kasuga Shrine, the tutelary Shinto shrine of the great aristocratic Fujiwara clan, since Kasuga is especially famous for its tame deer. During the Heian period the enormously powerful Fujiwara made this Kannon the protective Buddhist deity of the shrine, and this probably precluded the spread of his popularity among ordinary people. The Thousand-armed Kannon (Senju Kannon; Sahasrabhuja), introduced into Japan about the same time as the Fukukenjaku Kannon, far outstripped him in popularity, and many stat-

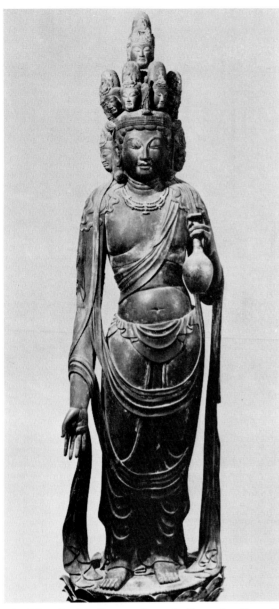

49. *Eleven-headed Kannon, Dogan-ji Kannondo, Kogen-ji, Shiga Prefecture. Wood; height, 177.3 cm. About mid-ninth century. (See also Figures 56, 73.)*

50. *Ashura, Kofuku-ji, Nara. Colors on dry lacquer; height of entire statue, 152.8 cm. About 734.*

ues of him were produced. The limited appeal of the Fukukenjaku Kannon can be deduced from the small number of statues of him that have been designated as national treasures or important cultural properties.

In 741, a learned monk of the Hosso sect copied one thousand sutra scrolls containing information about the Thousand-armed Kannon, with the result that faith in this deity spread far and wide. The famous T'ang Chinese monk Ganjin (in Chinese, Chien-chen), who arrived in Japan in 754 and established the Toshodai-ji in Nara in 759, commissioned the Thousand-armed Kannon that stands in the temple's Golden Hall today (Figs. 53, 72). Another statue thought to date from the same period is the seated Thousand-armed Kannon at the Fujii-dera, in Osaka (Fig. 11). Nara-period representations of this Bodhisattva usually possess one thousand arms, whereas those made in the Heian

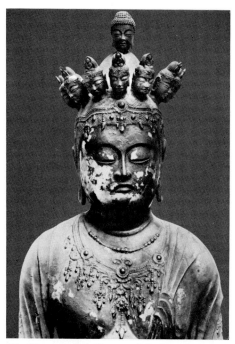

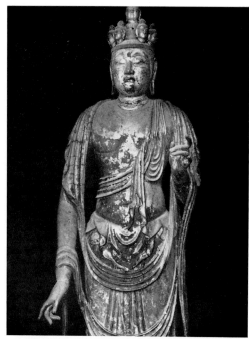

51. *Eleven-headed Kannon, Mie-dera, Gifu Prefecture. Dry lacquer; height of entire statue, 170.9 cm. Eighth century.*

52. *Eleven-headed Kannon, Shorin-ji, Nara. Dry lacquer; height, 209 cm. Second half of eighth century.*

period are often restricted to forty or forty-two.

As faith in the merits and powers of Kannon grew, representations of him assumed more complex and highly tantric forms culminating in the Thousand-armed Kannon, who came to be called the Lotus King (Rengeo), lord of all the other Kannon. Concurrent with this development, Kannon worship among the people tended to concentrate on this one manifestation and to penetrate even more deeply into the lower classes. The famous Sanjusangendo (Hall of Thirty-three Bays) at the Rengeo-in, in Kyoto, attests to the prestige of this Bodhisattva, for it houses one thousand and one statues of the Thousand-armed Kannon (Fig. 59). But the capital city of Kyoto did not monopolize devotion to this deity, and during the Heian period many noteworthy statues of him were made for provincial temples—for example, the statue at the Onjo-ji, in Shiga Prefecture (Figs. 31, 91).

In addition to the Eleven-headed Kannon, the Fukukenjaku Kannon, and the Thousand-armed Kannon, other manifestations of the deity were represented in the art of the Nara period. Statues of the Bato (Horse-head) Kannon, the Yoryu (Willow) Kannon, and the Nyoirin Kannon (Cintamanicakra), as well as records of the times, give adequate proof of the importance of this Bodhisattva in the history of Buddhism in Japan.

In the preceding pages we have looked mainly at the Buddhist figures worshiped in the Nara period, before the organized introduction of true Esoteric sects took place. As we have noted, there were many such figures, and they were often of high artistic merit. Two important and so far undiscussed points, however, underscore the significance of tantric, or Esoteric, elements in the worship of the Nara period.

The first of these points is the large number of

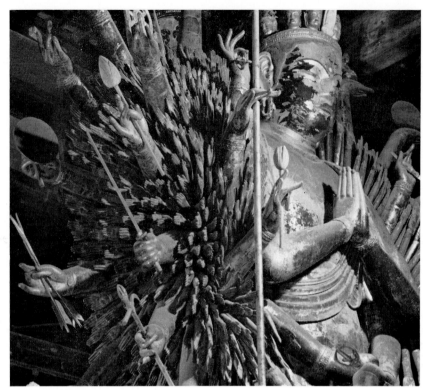

53. *Thousand-armed Kannon, Golden Hall, Toshodai-ji, Nara. Dry lacquer; height of entire statue, 535.7 cm. Second half of eighth century. (See also Figure 72.)*

Esoteric statues kept in the Nara temple Saidai-ji. The empress Koken, who reigned from 749 to 758, abdicated, and then reascended the throne to reign as Empress Shotoku from 764 to 770, ordered the influential priest Dokyo to build this temple and to fill it with representations of such basically Esoteric Buddhist divinities as the Peacock King (Kujaku Myo-o, or Mahamayurividyarajni), the Kongozo Bosatsu (Kongozo Bodhisattva), Bishamon Ten (Vaisravana), the Kato Bosatsu (Kato Bodhisattva), and others, some of which did not achieve central significance in the Heian period after Esoteric Buddhism had been established in an organized fashion.

The second point of interest is the nature of the Nara temple Daian-ji as a center to which large number of people came to study and train in Esoteric Buddhist practices. Teaching the precepts of the Kokuzo Bosatsu (Akasagarbha), the Daian-ji

not only instructed the above-mentioned priest Dokyo but also trained a line of other noteworthy priests leading directly to Kukai, the Heian-period prelate responsible for the full-scale introduction of Esoteric Buddhism. Moreover, since it is known that the *Dainichi-kyo* (Vairocana Sutra) was read in Japan in the late Nara period, it becomes clear that both the scriptural foundation and the basis for the popularity of the religion had already been laid by the time Kukai appeared on the scene.

The statues dating from the Nara-period, however, lack the strong Indian flavor of Heian-period statues of the same deities. The earlier ones, in fact, seem to be based largely on Chinese models which, in turn, closely followed the stipulations laid down in various sutras for the creation and design of devotional figures. On the other hand, instead of the idealized realism of most late-Nara sculpture for revealed Buddhism, Esoteric statues from the same

54. Fukukenjaku Kannon, Hokkedo, Todai-ji, Nara. Dry lacquer; height of entire statue, 360.6 cm. About 746.

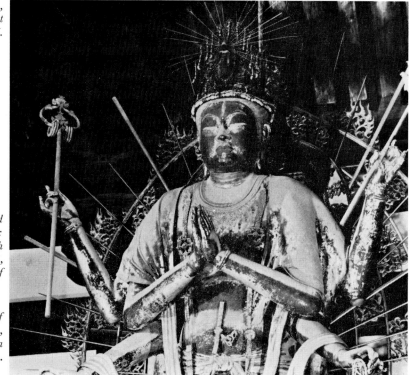

55 (bottom left). Eleven-headed Kannon with all heads of equal size: one of a set of drawings dealing with Buddhist iconography, Ninna-ji, Kyoto. Ink on paper. Second half of twelfth century.

56 (bottom right). Rear view of heads of Eleven-headed Kannon, Dogan-ji Kannondo, Kogen-ji, Shiga Prefecture. About mid-ninth century. (See also Figures 49, 73.)

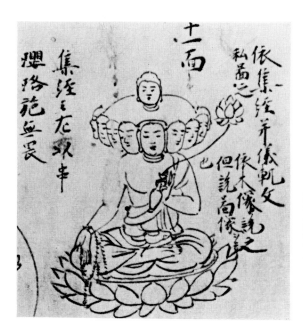

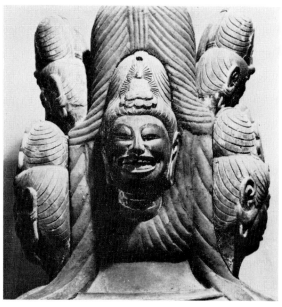

57. *Rushana Buddha (Vairocana), Golden Hall, Toshodai-ji, Nara. Dry lacquer; height of entire statue, 303 cm. About 759. (See also Figure 38.)*

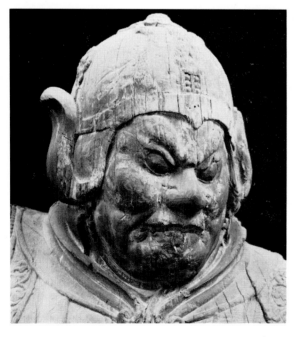

age tend to display volume and solemnity in the physique and awe-inspiring emotions in the face (Figs. 57, 58). Since these characteristics are not to be seen in Chinese statues of similar divinities, I attribute them to the reflection of a distinctively Japanese attitude toward religion. Although these traits are generally referred to as "esoteric," in fact they are more a direct expression of purely Japanese feelings projected on the borrowed vehicle of Buddhist sculpture. This is the way the Japanese of the age felt that gods should look.

58. *Zocho Ten, one of the Shitenno, or Four Celestial Guardians, Daian-ji, Nara. Wood; height of entire statue, 142 cm. Second half of eighth century.*

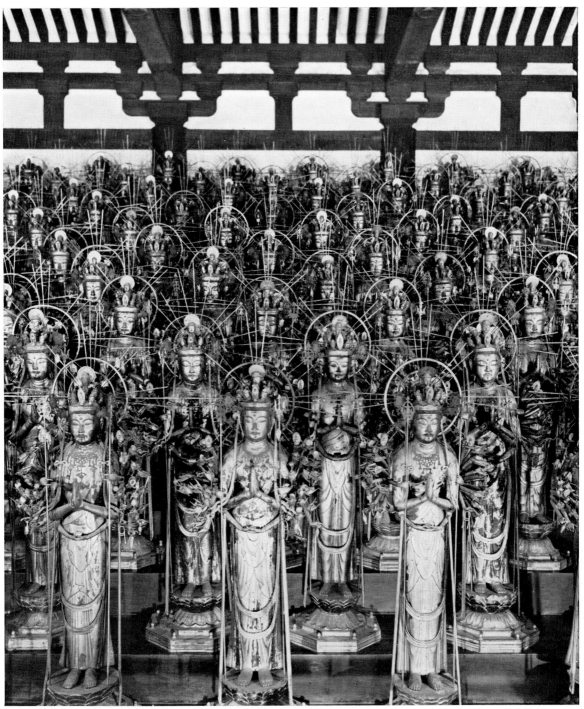

59. *Partial view of 1,001 statues of Thousand-armed Kannon, Sanjusangendo, Rengeo-in, Kyoto. Lacquer and gold leaf over wood; average height, 170 cm. Twelfth to thirteenth century.*

CHAPTER THREE

Esoteric Sculpture in the Heian Period

UP TO THIS POINT I have discussed primarily the Esoteric elements found in the Buddhist art of the Nara period, an age when neither of the two great Esoteric sects had yet been officially established in Japan. As the discussion has implied, the earlier Nara sects dealt mostly with philosophical ideas of great complexity and obscurity. More appealing to the hearts of the Japanese, however, were to be the magical practices, incantations, and ceremonies of Tendai (in Chinese, T'ien-t'ai) and Shingon (in Chinese, Chen-yen), the Esoteric sects introduced, respectively, by two of Japan's greatest priests, Saicho and Kukai, both of whom accompanied missions to T'ang China in the ninth century. During their sojourns at Chinese Buddhist centers of learning, Saicho (also known as Dengyo Daishi) and Kukai (Kobo Daishi) absorbed the knowledge that was later to enable them to develop traditions and customs that virtually overshadowed those of the older Nara schools. Philosophically and religiously it was Tendai, whose headquarters were established by Saicho at the great temple-monastery Enryaku-ji on Mount Hiei, near Kyoto, that was to have the most lasting effect, but it was Shingon that revolutionized Japanese Buddhist art for nearly two centuries.

After returning from T'ang China in 806, Kukai spent some time on the island of Kyushu, where he is said to have engaged in the production of Buddhist statuary in accordance with the rules set down in scriptures dealing with Esoteric divinities and practices. Not unlike the alleged fragments of the True Cross, many statues in numerous temples all over Japan are traditionally held to have been the work of this great priest. But the only ones that can reliably be said to have a direct connection with Kukai are those found in the two great temples with which he was intimately associated: the Kongobu-ji, on Mount Koya, which he founded in 816, and the To-ji, in Kyoto, of which he was appointed abbot in 823. Since the Kongobu-ji comes earlier in Kukai's career, I shall deal with it first.

In drawing up the plan of the Kongobu-ji, Kukai broke with established tradition and used the placement of the buildings to symbolize the contents of the *Dainichi-kyo* and the *Kongocho-kyo*, the two sutras most basic to Esoteric Buddhist beliefs. I have already commented on this layout, in which there are two pagodas placed on the right and left of a central axis, with the Lecture Hall in front and the priests' quarters in the rear. Unfortunately it is impossible today to know much about the sculpture contained in the two pagodas when they were first built, for they have been destroyed by fire on several occasions and then rebuilt, and most of the Buddha images date from a later age. Nevertheless,

60. *Portable shrine, Kongobu-ji, Mount Koya, Wakayama Prefecture. Said to have been brought from T'ang China by Kukai. Wood; height, 23.1 cm. Eighth century.*

among the Buddhas of the Diamond World in the West Pagoda today, the Dainichi Nyorai (Vairocana), shown in Figures 6 and 39 with several of its companions and in Figure 61 without its crown and its lotus pedestal, is thought to date from about 887, when the pagoda was completed. The oldest Buddha images at the Kongobu-ji that survived until fairly recent times were those that were destroyed in 1926, when the Lecture Hall burned down. Today they are known only through photographs, but they give us a clear intimation of the strong volition and faith that brought about the establishment of a new form of Buddhism in Japan, for they exhibit a style never seen before.

These seven statues represented Ashuku Nyorai (the Buddha Aksobhya), which stood at the center of the group, Kongo Satta (Vajrasattva), Kongo-o Bosatsu (Vajraraja), Kokuzo Bosatsu (Akasagarbha), Fugen Emmei Bosatsu (Vajramoghasamayasattva), Fudo Myo-o (Acala), and Gosanze Myo-o

(Trailokyavijaya). It appears that the statues were not arranged according to the prescriptions of any single sutra but according to Kukai's own ideas of what was proper for a place of study and practice like the Lecture Hall. It is not my intention to discuss each of the statues individually, but let us look for a moment at the Kongo Satta (Fig. 63), which had remained in almost perfect condition up to the time it was destroyed.

What we see in the photograph is a soft and amply fleshed form. The face is round and full, the headdress elaborate and stately. The lines of the wide-bridged nose sweep up in graceful curves to join those of the eyebrows—a feature not previously seen in Japanese statues of Buddhist divinities. It is not clear what Kukai took as a model for this statue (indeed, he may have had a painting and not sculpture in mind when he specified the appearance he wanted), but the expression and the mood are decidedly Indian. The connecting nose and eyebrows

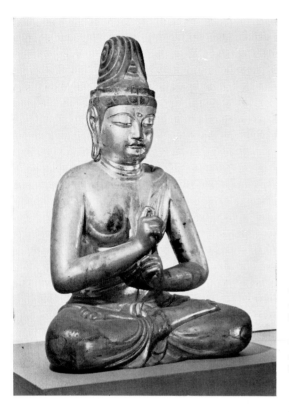

61. Dainichi Nyorai, West Pagoda, Kongobu-ji, Mount Koya, Wakayama Prefecture. Lacquer and gold leaf over wood; height, 98.5 cm. About 887. This is the Dainichi Nyorai of Figures 6 and 39 without its crown and lotus pedestal.

62 (opposite page, left). Fudo Myo-o, formerly in Lecture Hall, Kongobu-ji, Mount Koya, Wakayama Prefecture; destroyed by fire in 1926. Wood; height, 78.8 cm. First half of ninth century.

63 (opposite page, right). Kongo Satta, formerly in Lecture Hall, Kongobu-ji, Mount Koya, Wakayama Prefecture; destroyed by fire in 1926. Wood; height, 116.6 cm. First half of ninth century.

occur in Indian sculpture as early as the seventh and eighth centuries. Though the statue has Indian counterparts, the use to which such counterparts have been put is decidedly the result of Kukai's desire to give graphic representation to the ideals of Esoteric Buddhism. We have already noted the Esoteric doctrine that all men can become Buddhas in this world. Earlier statues, in the Nara period, depicted divinities as remote and austere beings unrelated to humanity, but, in the light of their hope of attaining Buddhahood in this life, the followers of Esoteric teachings preferred a sense of fleshly reality and intimacy. In fact, a humanized mood became one of the most important characteristics of Esoteric Buddhist art. It is a great pity that the seven statues in the Kongobu-ji Lecture Hall were lost.

The above-mentioned ninth-century Dainichi Nyorai (Figs. 39, 61), though somewhat stylized,

reveals the same full-fleshed approachability that was to characterize sculpture associated with the Kongobu-ji until the end of the Heian period (late twelfth century) and was to be adopted with amazing speed in sculpture throughout Japan soon after Kukai had established the style and the Esoteric teachings it represented. The most outstanding extant embodiments of the style are to be found in the group of statues at the To-ji (Figs. 64, 66, 67, 76–82, 110–13); the Nyoirin Kannon (Cintamanicakra) at the Kanshin-ji, in Osaka (Figs. 9, 83); and the five manifestations of the Kokuzo Bosatsu at the Jingo-ji, in Kyoto (Fig. 115).

Esoteric Buddhism was first organized and propounded on a broad scale in Heian-kyo (as Kyoto was anciently called) by Saicho and Kukai during the period between 806 and 823. Saicho, who returned from T'ang China earlier than Kukai, began teaching according to the law of the Mandala of

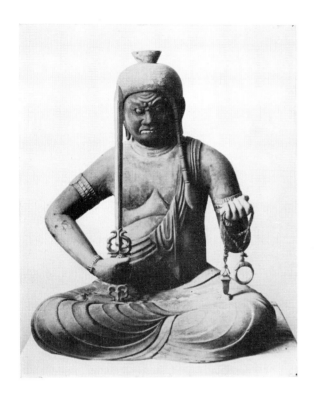
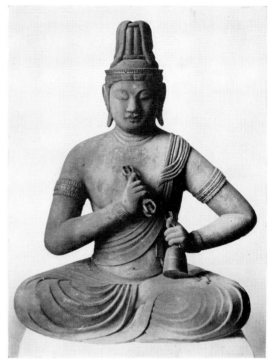

the Womb World at the temple Jingo-ji on Mount Takao, in Kyoto, as early as 805. But Esoteric teaching in the fullest sense did not begin until Kukai, establishing himself at the same temple, began instructing in both the Mandala of the Womb World and the Mandala of the Diamond World in 812. From this year on, and for several decades to follow, Kukai was extremely active.

During these years he gave firm theoretical foundations to the fragmentary beliefs in Buddhahood on this earth and other ideas taken from the *Dainichi-kyo* and the *Kongocho-kyo*. In addition he sponsored the importation of other Esoteric scriptures and, in accordance with their prescriptions, commissioned statues of the many-armed, often fiercely dramatic deities associated with Esoteric ceremonials. In short, with Kukai, Japanese Esoteric Buddhism entered its most vibrant phase of development.

Kukai was granted land to build the Kongobu-ji on Mount Koya by Emperor Saga, who had great and justifiable faith in this extraordinarily talented priest. So great indeed was imperial trust in his abilities that in 823 Kukai was made abbot of the To-ji (originally built in 794) and put in charge of developing it as an Esoteric temple dedicated to the prosperity and protection of the nation in general and the capital city in particular (Fig. 65). Although the temple was not completed during Kukai's lifetime, he enshrined in it a large number of statues symbolizing the Esoteric doctrines he had studied. Consequently, if one is to have an idea of the nature of early Esoteric Buddhist art in Kyoto, a close examination of the treasures of this temple is of primary importance.

Interestingly enough, although it contains a bold and dazzling collection of sculpture embodying the then stunningly new ideas of Esoteric Buddhism,

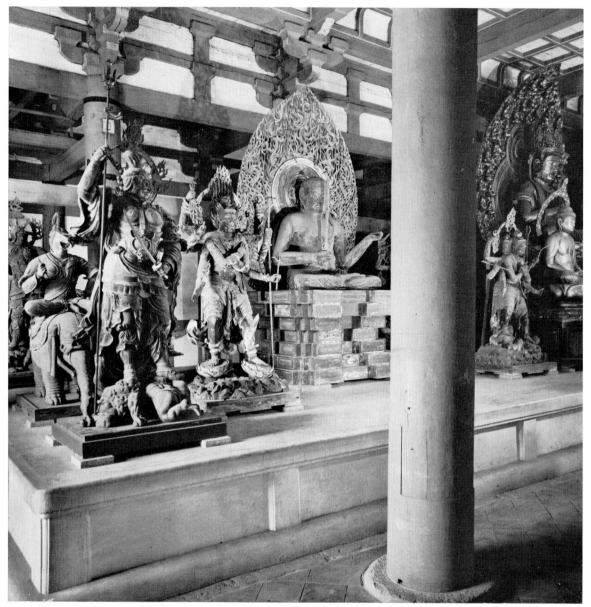

64. Interior of Lecture Hall, To-ji, Kyoto. Statues from left to right: Komoku Ten (at rear), Taishaku Ten, Zocho Ten, Gundari Myo-o, Fudo Myo-o, Gosanze Myo-o, Dainichi Nyorai, Amida Nyorai. (See also Figure 147.)

the To-ji follows the traditional Nara-period plot plan. In a straight line with the Great South Gate is the inner gate, beyond which stands the Golden Hall with the Lecture Hall and the Refec- tory behind it. The five-storied pagoda stands in the southeast corner of the compound, to the right as the visitor enters the Great South Gate.

The main image in the Golden Hall is that of

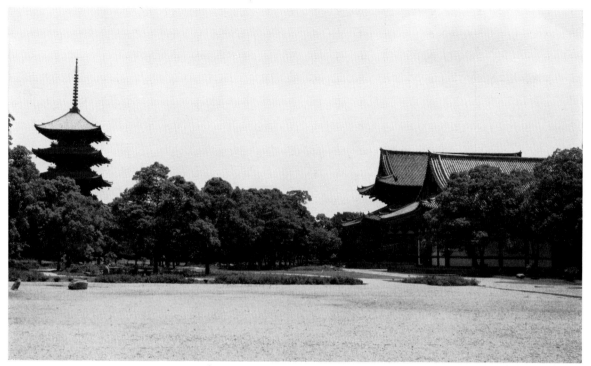

65. *To-ji, Kyoto, viewed from northeast corner of compound. At left: five-storied pagoda; at right: Lecture Hall and, behind it, Golden Hall.*

66. *Kongo Yasha Myo-o, one of the Five Great Kings of Light, Lecture Hall, To-ji, Kyoto. Painted wood; height, 172 cm. About 839.*

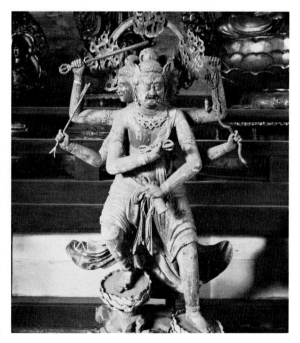

Yakushi Nyorai (Bhaisajyaguru), the Healing Buddha, with his guardian demigods, the Juni Shinsho, or Twelve Godly Generals, ranged around him in prescribed order. The present statue of Yakushi Nyorai is a Muromachi-period work that copies the Heian-period style of the original.

Although the five-storied pagoda of the To-ji has been destroyed by fire on three occasions, the present building, dating from the seventeenth century, nonetheless preserves much of the style and grandeur of an older age. From a document called the *Tohoki* it is possible to ascertain what the late-thirteenth-century rebuilding of the tower was like. It seems that there were statues of the Four Buddhas of the Diamond World placed on four sides

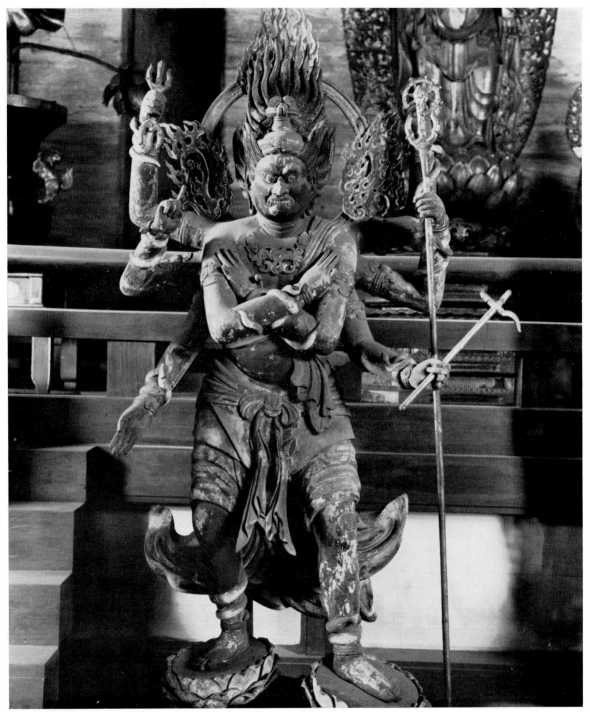

67. Gundari Myo-o, one of the Five Great Kings of Light, Lecture Hall, To-ji, Kyoto. Painted wood; height, 201 cm. About 839.

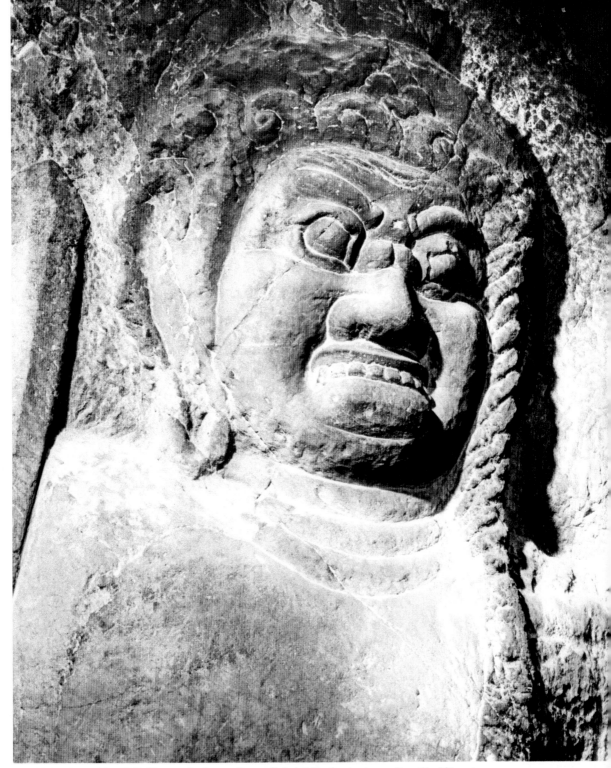

68. *Fudo Myo-o, Nisseki-ji, Toyama Prefecture. Stone relief; height of entire image, 3 m. Twelfth century.*

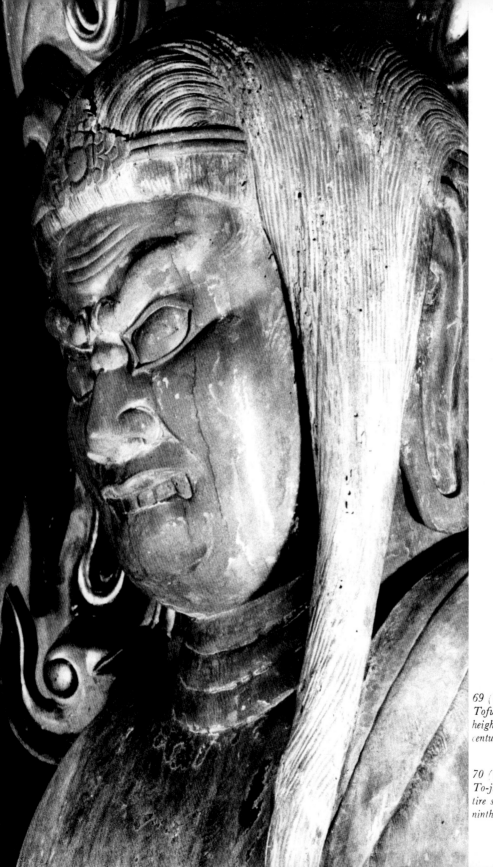

69 (left). Fudo Myo-o, Doshu-in, Tofuku-ji, Kyoto. Painted wood; height, 265 cm. Early eleventh century.

70 (right). Fudo Myo-o, Mieido, To-ji, Kyoto. Wood; height of entire statue, 185 cm. Second half of ninth century.

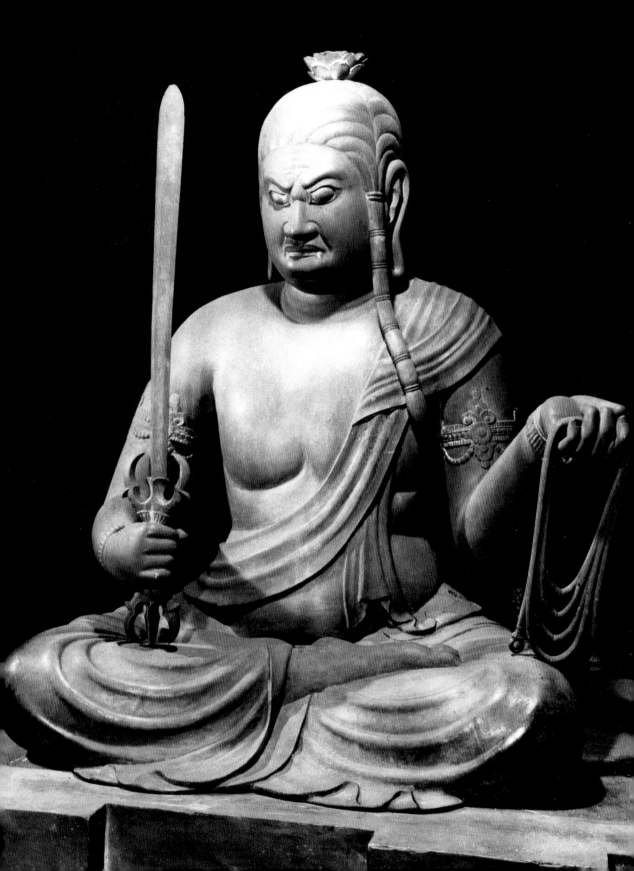

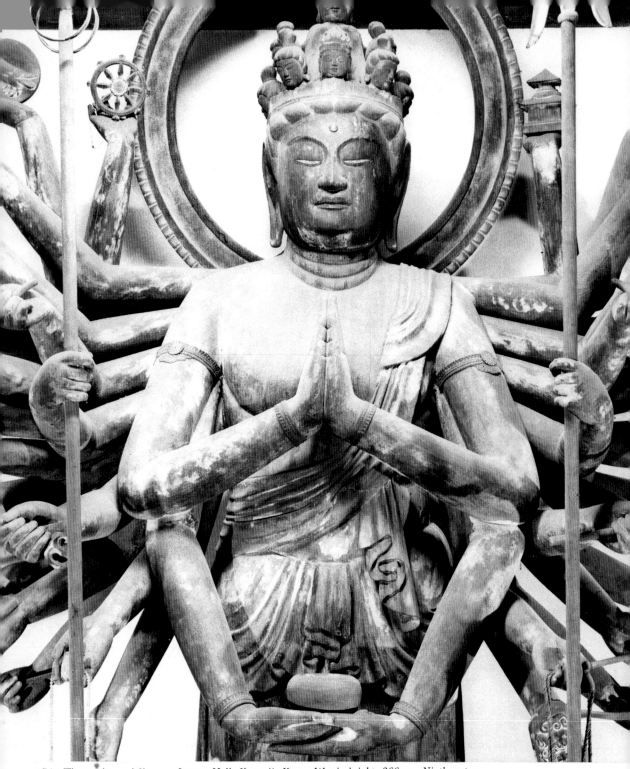

71. *Thousand-armed Kannon, Lecture Hall, Koryu-ji, Kyoto. Wood; height, 266 cm. Ninth century.*

72 (right). *Thousand-armed Kannon, Golden Hall, Toshodai-ji, Nara. Dry lacquer; height, 535.7 cm. Second half of eighth century.* (See also Figure 53.)

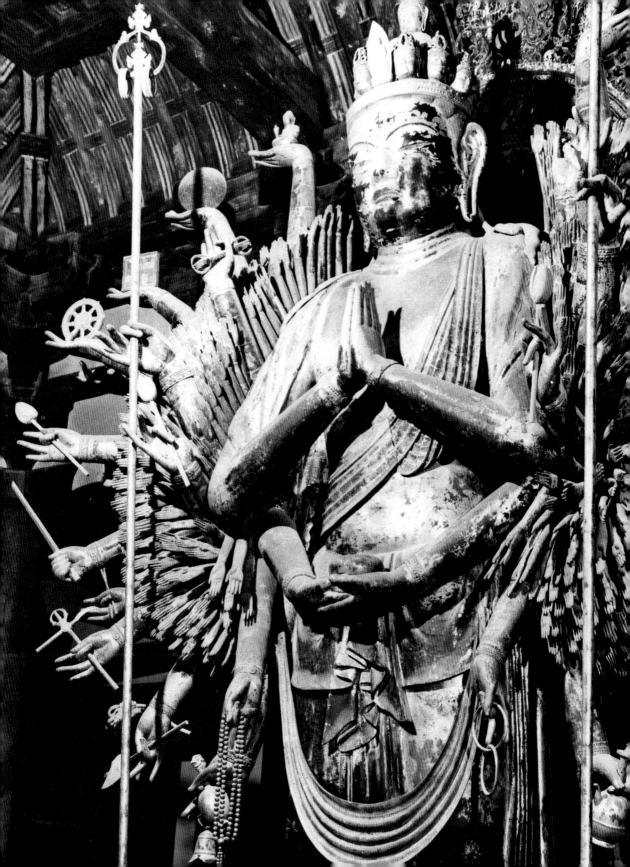

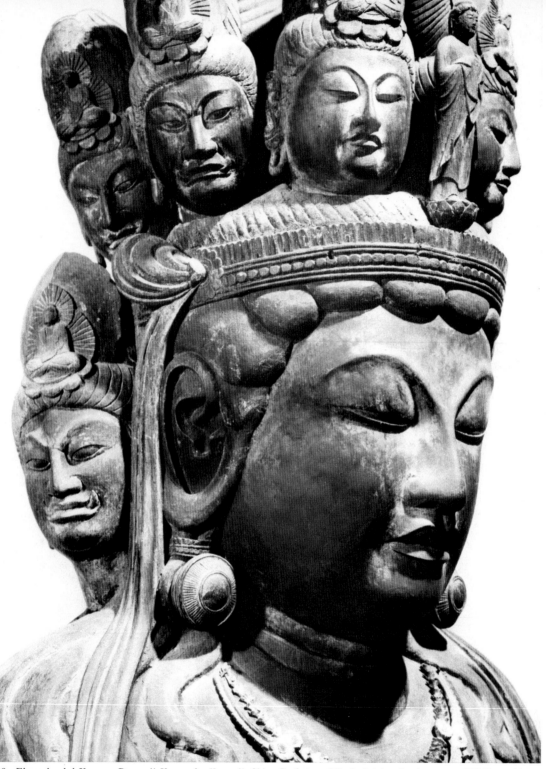

73. *Eleven-headed Kannon, Dogan-ji Kannondo, Kogen-ji, Shiga Prefecture. Wood; height of entire statue, 177.3 cm. About mid-ninth century. (See also Figures 49, 56.)*

74 *(right). Eleven-headed Kannon, Hokke-ji, Nara. Wood; height of entire statue, 99 cm. First half of ninth century. (See also Figure 85.)*

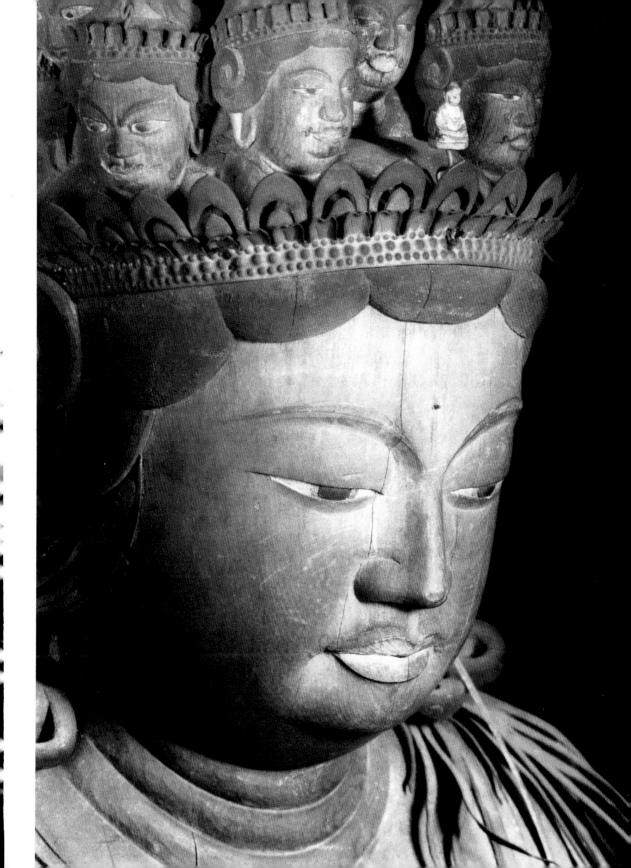

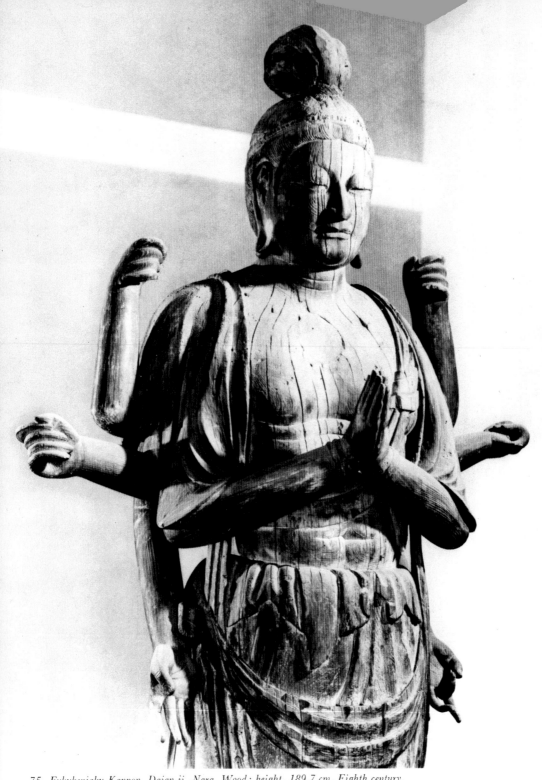

75. Fukukenjaku Kannon, Daian-ji, Nara. Wood; height, 189.7 cm. Eighth century.

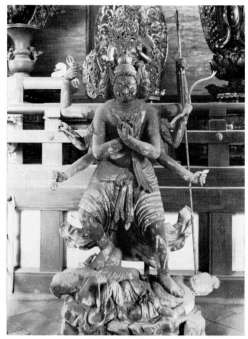

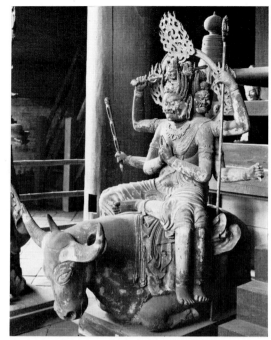

76. *Gosanze Myo-o, one of the Five Great Kings of Light, Lecture Hall, To-ji, Kyoto. Painted wood; height, 173 cm. About 839.*

77. *Daiitoku Myo-o, one of the Five Great Kings of Light, Lecture Hall, To-ji, Kyoto. Painted wood; height, 144 cm. About 839. (See also Figure 148.)*

78. *Fudo Myo-o, central figure of the Five Great Kings of Light, Lecture Hall, To-ji, Kyoto. Painted wood; height of entire statue, 173.2 cm. About 839. (See also Figure 111.)*

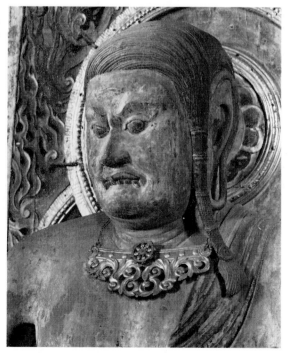

of the central pillar inside the first level of the building. The two west peripheral pillars were ornamented with pictures of these four Buddhas and of various Bodhisattvas. The two east peripheral pillars were similarly decorated, except that the Buddhas were those of the Womb World. The central pillar itself was not decorated, but the lower stages of the other pillars bore paintings of the Twelve Godly Generals and other divine beings. Although this building no longer exists, we can get an idea of its appearance by viewing the interior of the first level of the pagoda at the Daigo-ji, in Kyoto (Fig. 114). It must be remembered, however, that the placement of the paintings in the Daigo-ji pagoda is slightly different from that in the *Tohoki* descrip-

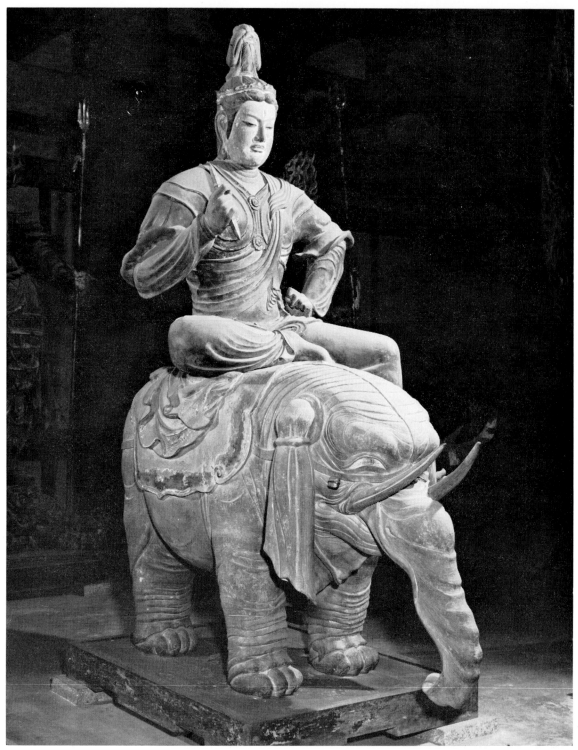

79. *Taishaku Ten, Lecture Hall, To-ji, Kyoto. Wood; height, 105 cm. About 839.*

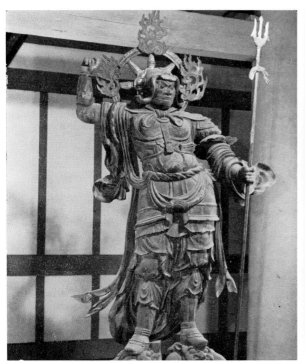

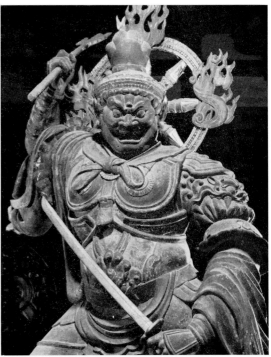

80. *Komoku Ten, one of the Shitenno, or Four Celestial Guardians, Lecture Hall, To-ji, Kyoto. Wood; height, 172 cm. About 839.*

81. *Jikoku Ten, one of the Shitenno, or Four Celestial Guardians, Lecture Hall, To-ji, Kyoto. Wood; height, 183 cm. About 839.*

tion of the former To-ji pagoda. Still, in both the destroyed To-ji pagoda and the one at the Daigo-ji, style and content were dictated by Esoteric Buddhist tradition.

The richest and oldest treasury of Esoteric Buddhist sculpture at the To-ji is to be found in the Lecture Hall, where statues of the Go Bosatsu (Five Bodhisattvas), the Go Dai Myo-o (Five Great Kings of Light), the Shitenno, Bon Ten, and Taishaku Ten are grouped around the Kongokai Go Butsu (Five Buddhas of the Diamond World), among which Dainichi Nyorai occupies the central position (Figs. 64, 66, 67, 76–82, 110–13, 147, 149). The sutras apparently do not prescribe the arrangement seen here, but it is traditional with the Shingon sect. Among the divinities, one sees first of all the Five Great Kings of Light and the Five Bodhisattvas, whose worship was unknown in the Nara

period. In addition, although their names are familiar from Nara times, Taishaku Ten, Bon Ten, and the Four Celestial Guardians have assumed forms quite different from those I have described as dating from the earlier age. The statues in the Lecture Hall of the To-ji represent concepts imported by Kukai from T'ang China.

The mood has changed, however, from the days when Kukai commissioned the statue of Kongo Satta (Fig. 63) at the Kongobu-ji, as one can see by examining the Bodhisattva statues—for example, the Kongoho Bosatsu (Vajraratna) in Figure 113. The heavy Indian influence is gone from the face, which is much more characteristically Japanese. Fleshiness has not yet reached the extreme to which it will go in the Jingo-ji statue of Yakushi Nyorai (Figs. 27, 84), although a certain balanced fullness persists in the body. The To-ji Bodhisattvas sug-

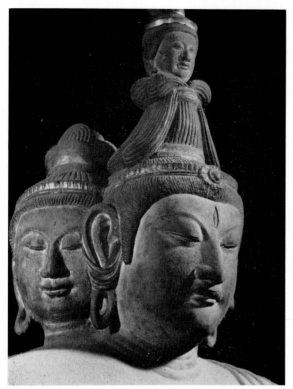

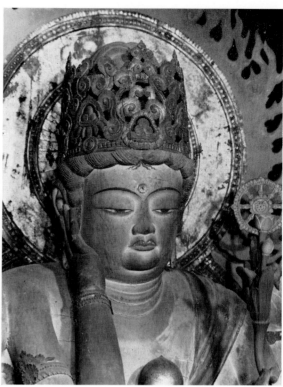

82. *Bon Ten, Lecture Hall, To-ji, Kyoto. Painted wood; height of entire statue, 1 m. About 839. (See also Figure 112.)*

83. *Nyoirin Kannon, Golden Hall, Kanshin-ji, Osaka. Painted wood; height of entire statue, 108.8 cm. About 836. (See also Figure 9.)*

gest that their sculptor was a man who had already mastered the techniques of his art, had refined his style, and had come to a full understanding of the newly imported Indian expressions.

The statues of the Five Great Kings of Light, with the larger-scale Fudo Myo-o at the center (Figs. 64, 66, 67, 76–78, 111, 148), are the first examples of such statues ever made in Japan. Deities bearing the title Myo-o were considered most efficacious when one addressed prayers to Dainichi Nyorai, of whom they are emanations. They are almost always ferocious in appearance though benevolent in nature. Their anger is directed against the wicked. The deity Kujaku Myo-o (Peacock Myo-o, or Mahamayurividyarajni), on the other

hand, has a calm and composed air (Fig. 179). In Japan the worship of the Five Great Kings of Light was particularly widespread and has continued to the present. Special devotion to Fudo Myo-o evolved from the worship of the divinities as a group.

Older representations of the Ni-o guardians and the Four Celestial Guardians will have prepared one for the glaring eyes, protruding tusks, and bristling coiffures of the Myo-o statues at the To-ji, but it is worth while to notice an important difference between the two groups. Whereas the Ni-o and the Celestial Guardians all have well-developed, power-charged, muscular physiques, the Myo-o, for all their violence of aspect, have soft, pliable limbs and

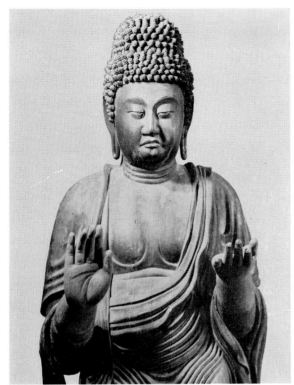

84. *Yakushi Nyorai, Golden Hall, Jingo-ji, Kyoto. Wood; height of entire statue, 170.3 cm. About 802. (See also Figure 27.)*

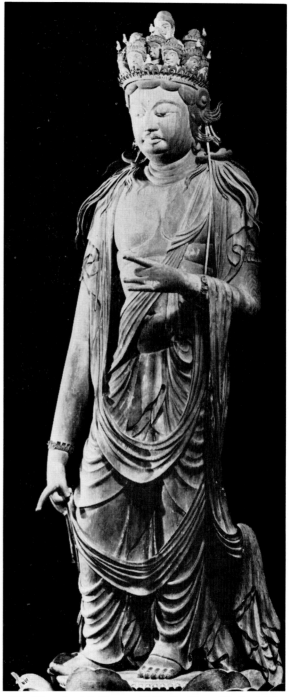

85. *Eleven-headed Kannon, Hokke-ji, Nara. Wood; height, 99 cm. First half of ninth century. (See also Figure 74.)*

fleshy trunks. In fact, there is a childlike quality about their bodies. There is a good psychological reason for this strange contradiction between face and figure in the Myo-o statues. The combination of their fierce expressions, multiple arms, and sometimes multiple heads, on the one hand, with the childishness of their bodies, on the other, underscores the mystic nature of their powers. Rules laid down in the sutras dictate that Fudo Myo-o should have the figure of a child, and in Japan the same figure has been adopted for the other Myo-o as well. Another statue of Fudo Myo-o (Fig. 70), preserved in the Mieido of the To-ji, is of approximately the same size as the one in the Lecture Hall. A sophisticated piece of sculpture, it too has a fierce

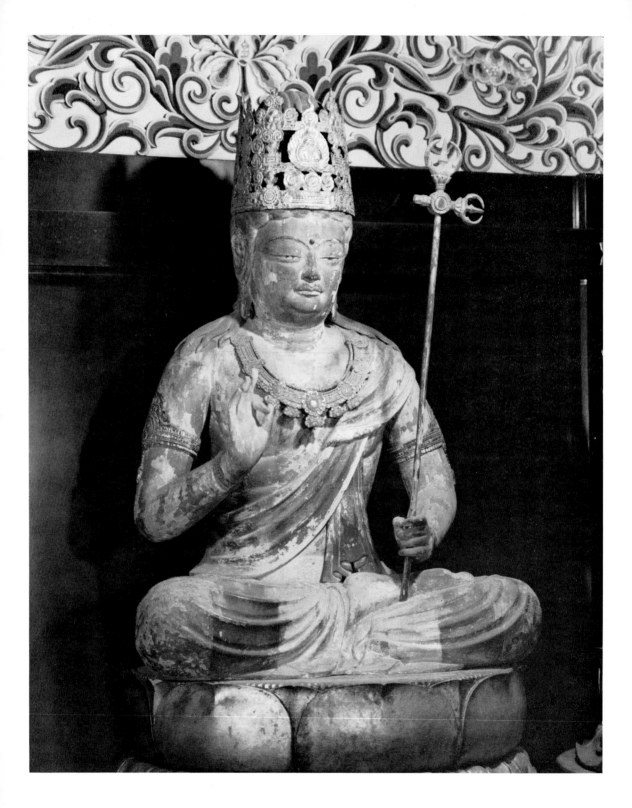

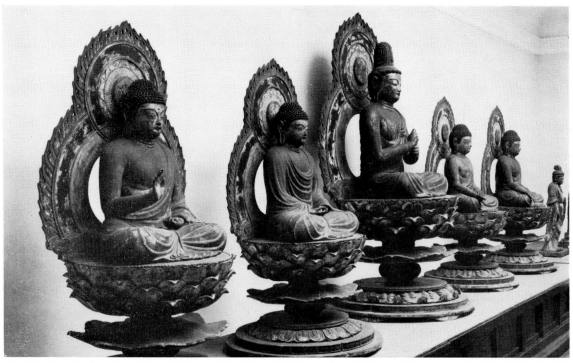

87. *The Five Buddhas of the Diamond World (Five Dhyani Buddhas), Anjo-ji, Kyoto. Left to right: Fukujoju, Muryoju, Dainichi, Hosho, Ashuku. Wood; height of central figure, 158.5 cm. About 851.*

face and a gentle-looking body. Although it is said by some to have been Kukai's own devotional image, its large size casts considerable doubt on this assumption.

The Taishaku Ten and Bon Ten statues, one at each end of the main altar in the To-ji Lecture Hall, reveal the purely Indian aesthetic aspects of Kukai's importations. Both have the same soft, fleshy quality that we have noted in other statues in the group. Bon Ten, who has four heads and four arms, is mounted on a delightful group of four geese (Figs. 82, 112). Taishaku Ten, who has only one head and two arms, does have three eyes, just as Bon Ten does in his main head, but his most striking accoutrement is the charming white elephant on which he rides (Fig. 79). Among the Four Celestial Guardians, Jikoku Ten (Fig. 81) and Zocho

Ten are most praiseworthy for the sense of power and action they convey. In fact, they can be numbered among the finest representations of these deities in all Japan.

By way of summary, I must say that novelty of expression is not the only thing that strikes the viewer of these statues in the To-ji Lecture Hall. In addition they all give an impression of great strength and size as well as a clear indication of Chinese influence. Finally, one of their values from both the aesthetic and the historical points of view is their number. Nowhere else in Japan can one find so large a collection of statuary with which it is certain that the great Kukai was directly related.

The Jingo-ji on Mount Takao, in Kyoto, and the Kanshin-ji, in Osaka, contain interesting pieces of

86. Hokai, one of the Five Great Kokuzo Bodhisattvas, Jingo-ji, Kyoto. Painted wood; height, 1 m. Dated 847.

Esoteric Buddhist sculpture that illustrate something about the way the new styles introduced by Kukai were infused with traditions already present since the Nara period. I have commented earlier on the extreme fleshiness of the statue of Yakushi Nyorai at the Jingo-ji (Figs. 27, 84), but more stylistically interesting are the statues of the five emanations of the Kokuzo Bosatsu at the same temple (Fig. 115), which were influenced by the Esoteric teachings of Kukai. Each of these statues (they are known collectively in Japanese as the Go Dai Kokuzo Bosatsu) has a name and a symbolic color. Hokai is white, Kongo is yellow, Hoko is blue, Renge is red, and Goyu is dark purple. Their great stylistic interest becomes immediately apparent when one compares them with the famous Nyoirin Kannon at the Kanshin-ji (Figs. 9, 83). The faces of the Bodhisattvas and the Kannon are so similar that one might suspect them to be the work of the same sculptor, but closer examination reveals remarkable stylistic differences, especially in the treatment of the bodies. The Kanshin-ji Kannon seems soft in a weirdly bewitching fashion, whereas the Jingo-ji Bodhisattvas, though certainly full in body, are sturdier and much less languid. Furthermore, the Kannon's draperies flow in gentle, soft lines, while those of the Bodhisattvas are rendered in formalized wave rhythms. In brief, the differences between the statues suggest that the Nyoirin Kannon is part of the pure stream of Kukai's Esoteric aesthetic, while the Jingo-ji Bodhisattvas represent a conservative Nara-style basic approach with a grafting on of Esoteric sculpture techniques. It is only in the faces that one senses a kind of family likeness.

Another good example of the early-Heian tendency to graft new Esoteric ideas on older aesthetic styles is the Eleven-headed Kannon at the Hokke-ji, in Nara (Figs. 74, 85). The body of this handsome statue clearly manifests Nara style, and the facial expression is somewhat stern. Pronounced abundance of flesh is shown by deep creases in the chest and abdomen. This last trait indicates connections with Esoteric aesthetic trends in the Heian period. The total impression of the figure is one of a firm foundation in conservative sculpture successfully blended with a new Esoteric content so strong that it almost overpowers the older flavor. Only a great artist could have produced this superlative work. The figure is unusual in that the right foot is slightly advanced, as if the Kannon were about to walk, the hem of the skirt is slightly raised, and the ends of the draperies are gracefully swept back. The almost lively movement creates a contrast with most Buddhist statuary, which is completely static.

At the Kyoto temple Anjo-ji, founded in 848 by the priest Eun for the empress Fujiwara Junko, there is a group of the Five Buddhas of the Diamond World (Fig. 87) done in a style closely related to the fleshy, heavy feeling of the purest Kukai Esoteric art. But this aesthetic trend gradually faded as time passed. In fact, aside from the statues already discussed, very few other pieces of sculpture in the Kukai tradition deserve special notice for their artistic merits. This may well be the result of an innate Japanese inability to understand and assimilate voluptuous imported Indian art. At any rate, as the Heian period progressed, the sensual style became formalized and ultimately vanished—to be replaced by the idealistic art of the late Heian, or Fujiwara, age (897–1185), of which there are too many fine examples to enumerate here.

CHAPTER FOUR

Esoteric Painting
in the Heian Period

WE HAVE ALREADY noted that the priest Saicho, after returning to Japan from T'ang China, taught the law of the Womb World at the Jingo-ji on Mount Takao. Upon the slightly later return of Kukai, who had mastered the law of both the Diamond World and the Womb World, Saicho received instruction from him. Later, Saicho was to found the great monastery-temple Enryaku-ji on Mount Hiei, but the basis of his teaching was the Tendai doctrine, which took on a profoundly Esoteric coloration only after his followers Ennin and Enchin returned from their own sojourns in China, bringing with them a large number of Esoteric Buddhist paintings. It is a fact that sculpture associated with Tendai Buddhism in Japan is extremely rare, whereas paintings of various deities are numerous. Almost the only extant statues from which it is possible to glean some knowledge about Tendai sculpture are the Thousand-armed Kannon of the Enryaku-ji (Fig. 90), the Thousand-armed Kannon of the Onjo-ji (Figs. 31, 91), and the Eleven-headed Kannon of the Kogen-ji (Figs. 49, 56, 73). Even these, however, date from the period of Ennin and Enchin and not from that of Saicho. Since statues of this type played an important part in certain Tendai ceremonials, there was probably a large demand for them. The Kogen-ji Kannon has pronounced Indian artistic elements—for example, the

comparatively large heads at the sides of the main head and at the apex—but the full form of the body can be traced more readily to China than to India. In fact, the style may have developed under the influence of works of art imported from China by Ennin and Enchin. Unfortunately nothing remains to throw further light on this interesting point. On the other hand, there is abundant information on Tendai pictures, and we know that some of the finest works in this genre produced in the Heian and Kamakura periods were influenced by works brought from China by Ennin, Enchin, and their followers or created in Japan under their guidance. There are no Tendai Esoteric paintings thought to date from the time of Saicho. The oldest one extant belongs to the age of Ennin, and all of them take a line of development quite different from that of paintings associated with Kukai's Shingon sect.

The first of these paintings to deserve attention is certainly the one of Fudo Myo-o known as the Yellow Fudo and enshrined at the Onjo-ji, but we shall have to view it through the medium of a copy, since the original is considered so sacred that photographs of it are forbidden. Reproductions of it in both painting and sculpture are not unusual in temples associated with the Onjo-ji, and one of the best of these reproductions is the painting in the Manju-in, in Kyoto (Fig. 118). Tradition says that the in-

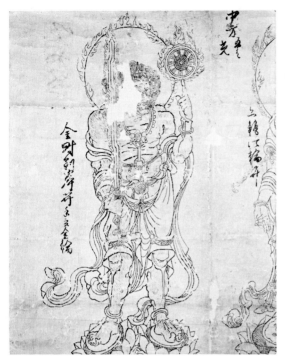

88. *Kongo Togan Bosatsu, Daigo-ji, Kyoto: one of a set of illustrations relating to the* Sutra of Benevolent Kings. *Ink on paper; height of image, 68 cm. Second half of twelfth century.*

89. *Fudo Myo-o, Daigo-ji, Kyoto: one of a set of illustrations relating to the* Sutra of Benevolent Kings. *Ink on paper; height of image, 45 cm. Second half of twelfth century.*

spiration for the Yellow Fudo came to Enchin while he was engaged in devotional studies and that he commissioned the painting in 838. Following no set iconography, this Fudo Myo-o is said to be solely the product of Enchin's imagination, although it seems likely that the source of his idea was a combination of pictures of the Kongo Togan Bosatsu and the Fudo Myo-o from a set of illustrations relating to the *Ninno-kyo* (Sutra of Benevolent Kings). The original illustrations are thought to have been brought from China by Kukai and were reproduced in later times (Figs. 88, 89).

The body of the Yellow Fudo, which fills most of the painting, is muscular and virile instead of childishly soft as the traditional iconography stipulates, and, in contrast to the usual lank hair, this Fudo's head is crowned with the tight rows of curls usually found in statues of Buddhas. The glaring,

wide-open, blazing eyes, however, are clearly derived from the basic nature of Fudo Myo-o, which is well expressed in pictures of the Kongo Togan Bosatsu, the prototypical form of Fudo.

In comparison with strictly conservative Shingon art, whose philosophy required that representations of Buddhas and other divine beings follow prescribed iconography, Tendai art developed under leaders like Enchin who took a much more critical and much wider view of well-established aesthetic regulations. This is indicated in later Japanese reproductions of iconographical works brought back by Enchin from China. In such reproductions one finds side by side old conservative representations of divinities and versions clearly revealing Sinicized innovations. The same eclectic tendency is seen in such iconographical works as the *Gobu Shinkan* and the *Taizo Zuzo,* which Enchin

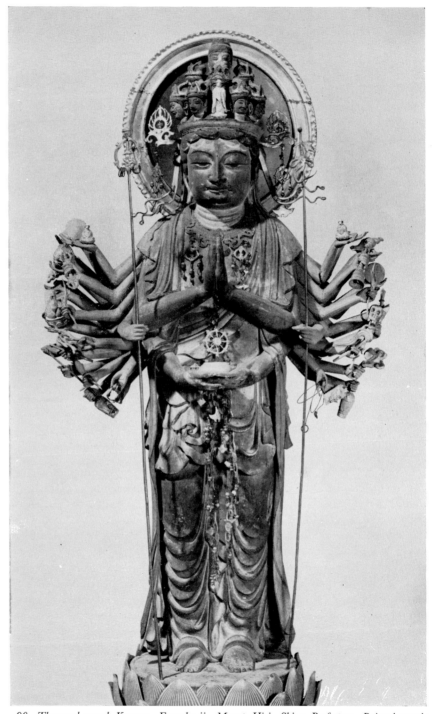

90. *Thousand-armed Kannon, Enryaku-ji, Mount Hiei, Shiga Prefecture. Painted wood; height, 51 cm. Second half of ninth century.*

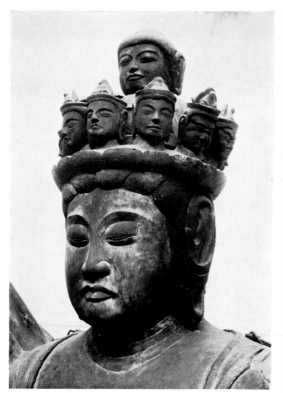

91. Thousand-armed Kannon, Onjo-ji, Shiga Prefecture. Wood; height, 175 cm. Early tenth century. (See also Figure 31.)

92. Kariteimo, Sambo-in, Daigo-ji, Kyoto. Colors on silk; height, 130 cm.; width, 78 cm. Second half of twelfth century.

also brought from China. These reproductions of documents originally brought from India to China by Prince Subhakarasimha (in Japanese, Zemmui) show sacred beings in new as well as old forms (Fig. 95). Since Enchin selected the contents of these two works, it is possible to learn a great deal from them concerning his attitude toward Esoteric Buddhist study. It goes without saying that the same attitude carried over into Enchin's conception of the form of Fudo as seen in the celebrated Yellow Fudo.

The influence of Enchin's innovational ideas persisted in a group of highly varied and outstanding Buddhist paintings by artists associated with the Onjo-ji. Such men as Toba Sojo Kakuyu, for instance, pioneered new spheres in Buddhist painting, and the results of their work can be seen in richly varied pictures like the Red Fudo in the Myo-o-in,

on Mount Koya (Fig. 13), and the Blue Fudo at the Shoren-in, in Kyoto (Fig. 119). Two other fine works in the same Onjo-ji tradition are the Kariteimo (Hariti) and the Emma Ten (Yama), both now at the Daigo-ji, in Kyoto (Figs. 92, 120).

Despite the fact that the extant paintings known to date from the Heian period are for the most part aesthetically superlative, their number, in comparison with that of sculptural works from the same age, is small. Nonetheless, they offer interesting clues for the solution of several problems in connection with the development not only of Japanese Buddhist painting but also of Japanese art in general. From its earliest stages, Esoteric Buddhism held that paintings and sculpture were very important means of transmitting religious teachings. In a list of works imported into Japan from China,

93. *Ryuchi Bosatsu, To-ji, Kyoto. Colors on silk; height, 212.6 cm.; width, 151.2 cm. Dated 821.*

94. *Ryumyo Bosatsu, To-ji, Kyoto. Colors on silk; height, 212.9 cm.; width, 151.1 cm. Dated 821.*

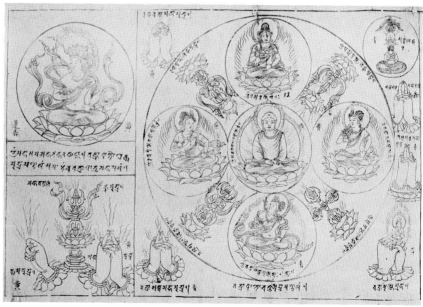

95. *Section of* Gobu Shinkan *scroll (an iconographical work), Onjo-ji, Shiga Prefecture. Ink on paper; height, 30.3 cm. Dated 855.*

96 (left). Ishana Ten, one of the Twelve Celestial Beings, Saidai-ji, Nara. Colors on silk; dimensions of entire painting: height: 160 cm.; width, 134.5 cm. First half of ninth century.

97 (right). Sui Ten, one of the Twelve Celestial Beings, Saidai-ji, Nara. Colors on silk; dimensions of entire painting: height, 160 cm.; width, 134.5 cm. First half of ninth century.

been frequently retouched, their general mood is most decidedly Heian. The main figures, which fill most of the picture area, are drawn with ease and generosity. The clothing they wear is sparsely ornamented, but the attendants at their sides and the clouds and water in the background provide all the decoration that is wanted. There is something reminiscent of the mandala in all these pictures.

In comparison with these early-Heian works, the pictures of the Twelve Celestial Beings painted in 1127 and now in the collection of the To-ji show interesting aspects of the changes in style that took place during the late Heian, or Fujiwara, period. Whereas the Saidai-ji pictures are almost filled with the figures of the central deities, the To-ji versions (Figs. 99, 117) are balanced compositions with the main figures and the attendants placed against spacious backgrounds. The colors and decorative designs of the costumes are rich and elegant, and lavish use is made of fine patterns in cut gold leaf. Fondness for ornament and luxury, one of the most salient characteristics of Fujiwara-period art, is reflected in these pictures, but the rigidly frontal placement hints at a conscious attempt to suggest the formal expression of the mandala.

There are both similarities and differences in the composition of these two sets of paintings. In the Saidai-ji group, as we have noted, the bulk of the area of each painting is filled with the figure of the main image. There was a very serious religious reason for this approach. The aim of the early-Heian painters of Esoteric Buddhist pictures was not so much to arrange a pleasing composition as to place before the eyes of the devotee a visible manifestation of the divinity. In later paintings, however, this spiritual element seems to have been overlooked. Instead of simply displaying the form of the deity, the paintings give him a highly pictorial representation.

Kukai himself commented: "Truth is neither words nor color and form. Although words may be used in transmitting truth, people can be made to *feel* truth only by means of forms and colors. Esoteric teachings hold that profound truths are difficult to express in written or spoken words. For those who find enlightenment on subtle points difficult, it is essential to resort to pictorial representations to inspire a sense of hidden meanings."

We know from existing documents that Kukai commissioned the production of many Buddhist paintings, but the only surviving ones that can be directly attributed to his sponsorship are the portraits of the Bodhisattvas Ryuchi (Nagabodhi) and Ryumyo (Nagarjuna) at the To-ji (Figs. 93, 94). In addition, however, the paintings of the Juni Ten, or Twelve Celestial Beings (Devas), at the Saidai-ji, in Nara (Figs. 96, 97, 109), are probably works of Kukai's period or some time close to it. Although they have deteriorated with age and have

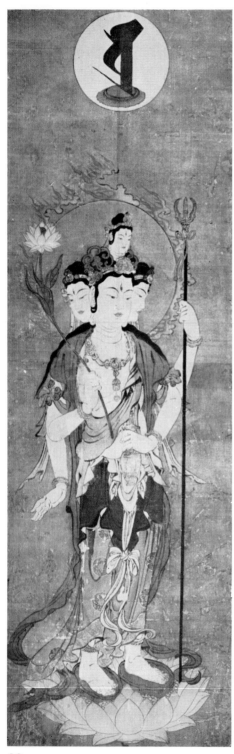

98. *Bon Ten, one of the Twelve Celestial Beings: panel from a folding screen, Tō-ji, Kyoto. Colors on silk; height, 130.3 cm.; width, 42.1 cm. Dated 1191.*

Since pictures of the Twelve Celestial Beings were usually placed on the walls of the religious training hall as a form of spiritual protection, they were originally hanging scrolls. Later, however, they were often used to decorate the surfaces of pairs of sixfold standing screens (Fig. 98).

It has been noted above that frontality of the image indicates a mandala-type representation. The tendency to employ mandala elements in the composition of Esoteric paintings increased as time went on and sometimes led the painters to surround their images with halo-like moon circles like those in the painting of the Fugen Emmei Bosatsu (Vajramoghasamayasattva) at the Matsu-no-o-dera, in Kyoto (Fig. 121). This design is similar to the one used in the Mandala of the Diamond World, where Dainichi Nyorai is in the center of the circle. Still, even in paintings that are not, strictly speaking, mandalas, other Bodhisattvas are found in this position.

In my discussion of various kinds of Esoteric art, I have used the word "mandala" on several occasions, but I have not yet explained it adequately. The time has come to do so, for I must now discuss this kind of representation as an art form. A mandala is a representation of the essentials, the heart of things, in their complete and perfect form. In application to religious ceremonies and training, the word came to refer to gatherings of the faithful, "genesis," "altar," and the place of training itself. In order to give the perfect world of the mandala visible manifestation, all things—symbolically speaking—were gathered together in prescribed order on the temple altar standing in the middle of the place of religious training. Today the word "mandala" generally calls to mind the pictures hung as scrolls on temple walls. In fact, however, the scroll pictures are no more than representations of the symbolic re-creation on temple altars of the

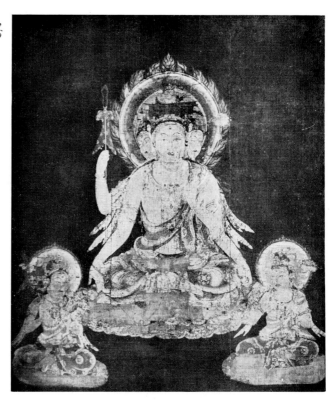

99. *Bon Ten, one of the Twelve Celestial Beings, To-ji, Kyoto. Colors on silk; height, 144.2 cm.; width, 126.6 cm. Dated 1127.*

world in its complete and perfect form. In the distant past, instead of being hung on the walls, such pictorial mandalas were spread out on the tops of altars, especially for such important ceremonies as ordinations. The only two surviving altar-top mandalas, dating from the Heian period and now in the To-ji, are both designated by the Japanese government as important cultural properties.

In religious painting there are at least three approaches to the presentation of ideas or stories. One large picture may be a composite of many scenes, or a number of small pictures may be devoted to one scene each. Again, a religious picture is sometimes no more than a representation of the forms of a collection of deities. All three of these devices may be found in almost all religious art, including that of both Esoteric and Exoteric Buddhism and that of Christianity as well. In many cases these approaches employ a kind of artistic narrative style to elucidate the ideas, but this is not the case with Esoteric Buddhist mandalas. Mandalas, which express ideological content only, may be divided into two major types: the Mandala of the Womb (material) World and the Mandala of the Diamond (spiritual) World. Sometimes, as we have noted earlier, these two are combined in what is known as the Mandala of the Two Worlds.

At a glance the composition of mandalas seems extraordinarily complex, but they can be understood quickly if they are examined in terms of their major divisions and subordinate parts. In the Mandala of the Womb World the center of the picture is an eight-petaled lotus in the very middle of which sits Dainichi Nyorai as the source of all organic life. On the eight lotus petals around him sit the Four Dhyani Bodhisattvas and the Four Dhyani

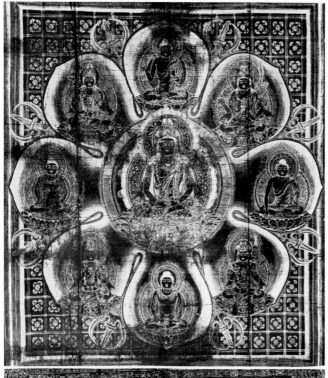

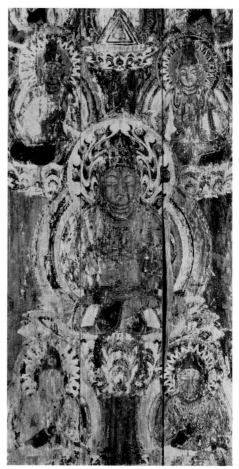

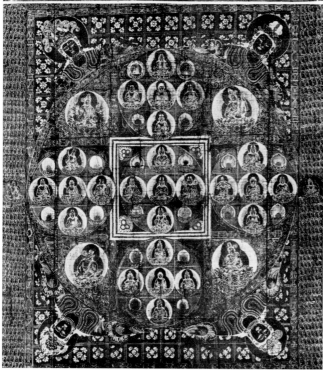

100 (top left). Dainichi Nyorai (center) and attendant deities on eight-petaled lotus: detail from Womb World section of Mandala of the Two Worlds, Kojima-dera, Nara. Gold and silver on patterned indigo silk; dimensions of Womb World section of mandala: height, 349.1 cm.; width, 307.9 cm. About 1000.

101 (bottom left). Various deities of the Diamond World: detail from Diamond World section of Mandala of the Two Worlds, Kojima-dera, Nara. Gold and silver on patterned indigo silk; dimensions of Diamond World section of mandala: height, 351.5 cm.; width, 297 cm. About 1000.

102 (top right). Dainichi Nyorai (center) and four Bodhisattvas of the Womb World: detail from paintings on central pillar of five-storied pagoda, Daigo-ji, Kyoto. Colors on wood; width of panel, 67 cm. Dated 951.

103. Dainichi Nyorai: detail from Diamond World section of Mandala of the Two Worlds, Jingo-ji, Kyoto. Gold and silver on patterned purple silk; dimensions of Diamond World section of mandala: height, 393.1 cm.; width, 338.3 cm. About 831.

Buddhas, who are their spiritual fathers (Fig. 41). The lotus is surrounded by a delineating square beyond which are eight precincts filled with Bodhisattvas and Myo-o. On the four sides of the very periphery of the picture are many guardian divinities. There are centrally placed gates on the sides of each precinct. The figures in the center of the mandala are drawn large, but the others decrease in size toward the periphery. The general plan is not unlike that of an ancient castle with gates in four directions and with the king in the center, from which vantage point he maintains surveillance over his retainers and soldiers. It is probable that the designers of the form made allegorical use of the social structure of the distant past and replaced the king, the symbol of political power, with Dainichi Nyorai, the source of all manifestations of the organic world. Other Buddhist sects sometimes use a similar configuration in which other divinities appear. For example, at the Hase-dera there is a mandala organized along similar lines but employed to illustrate the *Lotus Sutra* of Exoteric Buddhism.

Representing an entirely different line of religious thought and therefore assuming a different composition, the Mandala of the Diamond World is much more complex than the Mandala of the Womb World. Instead of portraying one major deity in one large picture, it is a set of nine small mandalas composed of combinations of the circle and the square. The mandala's nine divisions are in fact three lines of three squares, each of which contains several pictures. The simplest of the divisions is the top-center picture, in which a circle inscribed in a square surrounds one figure—that of Dainichi Nyorai, in this case representing the

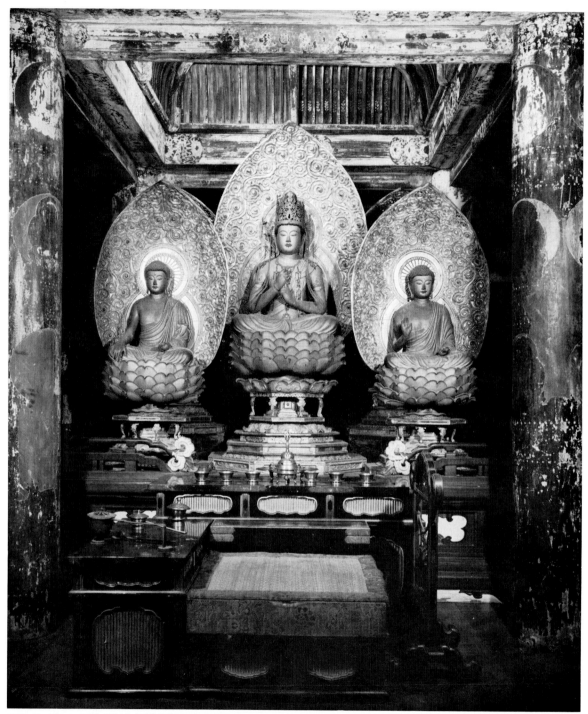

104. Buddhas of the Diamond World, pagoda of Kongosammai-in, Mount Koya, Wakayama Prefecture. Painted wood; height of central figure: 79 cm. About 1223.

105. *Mandala of the Two Worlds, Jizo-in, Kyoto. Carved and painted wood. Diamond World (left) : height, 42.4 cm.; width, 35.9 cm. Womb World (right) : height, 42.9 cm.; width, 36.6 cm. Twelfth century.*

sun (Figs. 10, 14, 103). The other pictures may include many figures, but they all consist of squares containing circles which are in turn divided into subsections (Figs. 101, 105). The plan of the Mandala of the Diamond World is set forth in the *Diamond Crown Sutra.*

The Mandala of the Womb World and the Mandala of the Diamond World, considered separately, represent matter and the spirit, but the tenets of Esoteric Buddhism, emphasizing the possibility of attaining Buddhahood in this life, require a union of the two. Therefore the Mandala of the Two Worlds is essential to the realization of the Esoteric Buddhist ideal. I have already pointed out the general plan of the Kongobu-ji, Kukai's temple on Mount Koya, as a symbolization of the two worlds. The oldest extant paintings of the Mandala of the Two Worlds are the one done in gold and silver on

a purple background and now in the possession of the Jingo-ji (Fig. 103), a multicolor one at the To-ji (Figs. 14, 41), and the one in gold and silver on an indigo ground, now at the Kojima-dera, in Nara (Figs. 100, 101). The ground-level room of the five-storied pagoda at the Daigo-ji is ornamented with paintings which, as a group, make up the Mandala of the Two Worlds (Figs. 106, 114). Some of the figures are painted on a board covering around the central pillar of the pagoda, others are on the four corner posts, and still others adorn the four walls. It is possible that the original pagoda at the To-ji served as an inspiration for the decorations in the Daigo-ji pagoda, but today the Daigo-ji mandalas are the oldest survivors of their type.

Other examples of the two mandalas presented in this form are those in the Golden Hall of the late-Heian-period Chuson-ji, in Hiraizumi (Iwate

106. *Interior of ground level of five-storied pagoda, Daigo-ji, Kyoto, showing mandala paintings. This level of the pagoda is 6.63 meters to a side. (See also Figure 114.)*

Prefecture); in the Amidado of the Kamakura-period Hokai-ji, in Kyoto; and in the two-storied pagodas (also Kamakura period) of the Ishiyama-dera, in Otsu (Shiga Prefecture), and the Kongo-sammai-in, on Mount Koya (Fig. 104). All of these were probably influenced by earlier paintings such as those in the larger of the two original pagodas at the Kongobu-ji.

It is interesting to note that the Mandala of the Two Worlds brought from China by Kukai and kept at the To-ji was so much used that it disintegrated by 821 and was replaced by a new one. This was later copied on several occasions, and the version that is today the principal mandala of the To-ji was painted during the Genroku era (1688–1703) of the Edo period.

CHAPTER FIVE

The Spread of Esoteric Art

NOT TOO LONG AFTER the establishment of the two main Esoteric Buddhist sects in Japan—Shingon and Tendai—they and their great temples, the To-ji, the Kongobu-ji, and the Enryaku-ji, brought most of the people of Kyoto under their religious sway. In addition they were even able to transmit certain Esoteric elements of faith to the great temples of Nara, the stronghold of conservative sects of Exoteric Buddhism. Since Esoteric doctrines offered Buddhahood during this life, their appeal was not limited to the wealthy aristocrats but extended rapidly to the masses both in the capital and in the provinces. It must be remembered, of course, that ever since the Nara period certain religious ascetics had departed from the centers of population for rural mountain retreats where they practiced strict religious discipline. There can be no doubt that these men did much to prepare the soil for receiving the seed of Esoteric Buddhist faith.

Religious edifices erected by nations and great lords, no matter how grandiose their scale, inevitably suffer the same fate as the powerful governments and men who build them. Consequently, their prosperity or poverty hangs by a very slender human thread indeed. In contrast, those temples and other places of worship that win the heart of an entire people thrive with that people. This has always been so and will continue to be so until the spirit of religion perishes from the soul of man.

A similar phenomenon explains the long-lasting popularity of certain divinities. For example, the ascetics who, as early as the Nara period, carried the Buddhist faith into the mountains of Japan doubtless introduced many Buddhas and other divine beings, but none gained and held the heart of the people with the tenacity of Kannon and Fudo Myo-o. Kannon, who was already worshiped in the Nara period, is believed to be able to grant the wishes of men's hearts. Faith in him gained great force in the Heian period, when there was instituted a pilgrimage to thirty-three holy places in western Japan associated with him. The Eleven-headed Kannon was the most popular of the several manifestations of this divinity worshiped in the Nara period, and the Tendai sect continued to center much attention on him. But the most widely worshiped Kannon in the Heian period was the Thousand-armed Kannon, the one counted mightiest of all. In fact, by the end of the Heian period the Thousand-armed Kannon had come to represent all other manifestations of the divinity. The many very old Kannon statues found in rural areas in Japan must be seen against this historical background.

The benevolent though vicious-looking Fudo Myo-o is discussed in the two sutras *Fukukenjaku-kyo* and *Dainichi-kyo*, but the oldest representation of him is found in the Mandala of the Womb World. Worship of Fudo Myo-o, however, did not arise from the sutras but developed from the worship of the Five Mighty Bodhisattvas (Go Dairiki Bosatsu), with whom are associated the Five Great Kings of Light, who, as we have seen, have Fudo Myo-o as

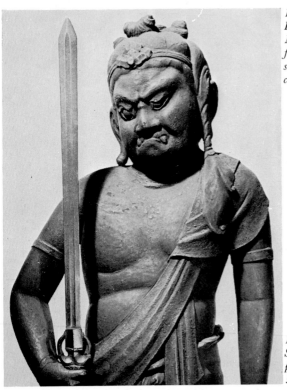

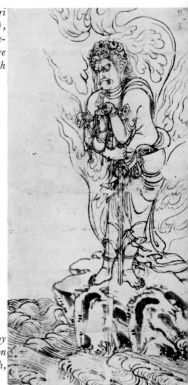

107. Fudo Myo-o (the Namikiri Fudo), Nan-in (Minami-no-in), Mount Koya, Wakayama Prefecture. Wood; height of entire statue, 91 cm. Second half of ninth century.

108. Fudo Myo-o painted by Shinkai, Daigo-ji, Kyoto. Ink on paper; height, 123 cm.; width, 51.3 cm. Dated 1282.

their central figure. Fudo, as a servant of the Buddha, has a childish body, but, because he combats evil and symbolizes the destruction of wickedness, his face is filled with rage. His usual accessories are a sword and a lasso. Worship of Fudo assumed various severe forms, including a ritual in which one first stood under a plunging waterfall to purify body and spirit and then, after building a fire on the altar hearth, burned incense, offered prayers, and performed a number of austerities.

It is interesting to note the striking difference between the natures of Kannon and Fudo and the respective rituals in which they were worshiped. Kannon is nearly always depicted as the soul of serenity, and worship of him has always been calm and gentle—almost feminine in mood. As a matter of fact, a great deal of confusion exists concerning the sex of this divinity. One of its most famous manifestations is Kuan-yin, the Chinese goddess of mercy, but in Japan the form is either masculine, as

indicated by a thin mustache, or virtually sexless. By sharp contrast, not only the forms of the statues of Fudo but also the forms of his rituals are thoroughly masculine and charged with vigor and action. The male aspects of Fudo and his rituals were without doubt much reverenced by the mountain ascetics who became the mentors of the rural faithful, and it is not surprising that the popularity of this deity steadily increased in rural districts. Although the urban aristocrats of the Heian period also paid great homage to Fudo, his worship spread faster and endured longer among the common people. He became especially widely revered after the Muromachi period, when a regimen of training and ascetic disciplines centering on his worship was established.

Outstanding representations of Fudo Myo-o in Shingon temples are the seated statue in the Lecture Hall of the To-ji (Fig. 111) and the painting in the above-mentioned gold-and-silver Mandala of

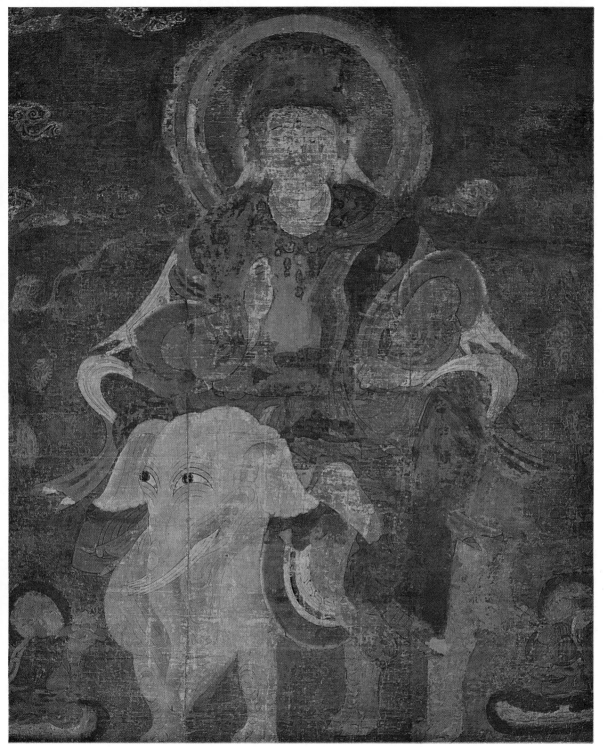

109. *Taishaku Ten, Saidai-ji, Nara. Colors on silk; height, 160 cm.; width, 134.5 cm. First half of ninth century.*

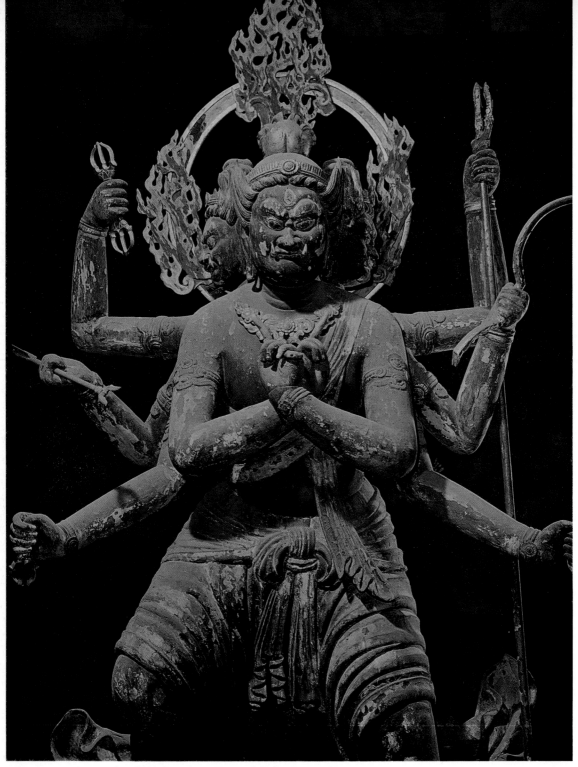

110. *Gosanze Myo-o, one of the Five Great Kings of Light, Lecture Hall, To-ji, Kyoto. Painted wood; height, 173.6 cm. About 839.*

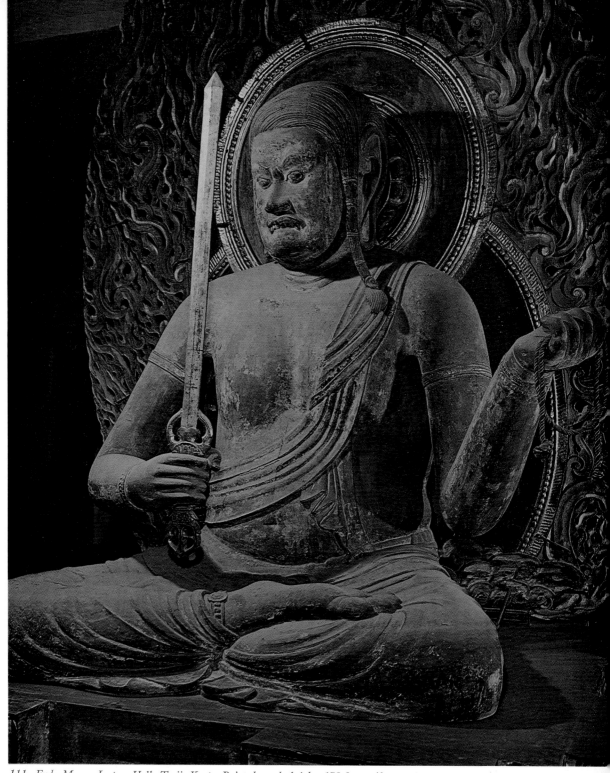

111. Fudo Myo-o, Lecture Hall, To-ji, Kyoto. Painted wood; height, 173.2 cm. About 839. (See also Figure 78.)

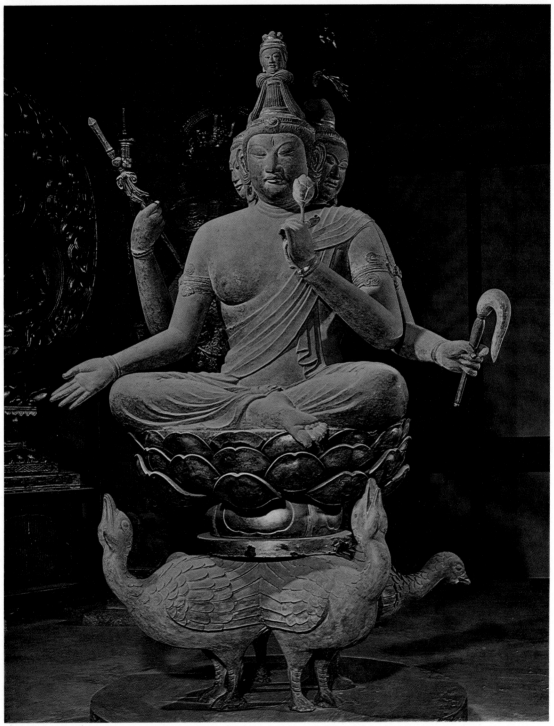

112. *Bon Ten, Lecture Hall, To-ji, Kyoto. Painted wood; height, 1 m. About 839. (See also Figure 82.)*

113. *Kongoho Bosatsu, one of the Five Great Bodhisattvas, Lecture Hall, To-ji, Kyoto. Lacquer and gold leaf over wood; height,* ▷
96 cm. About 839.

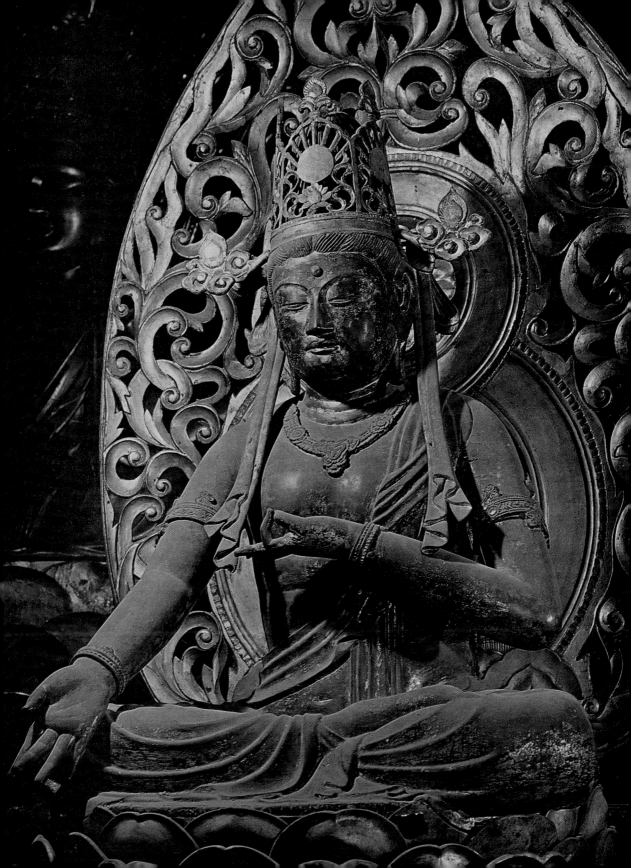

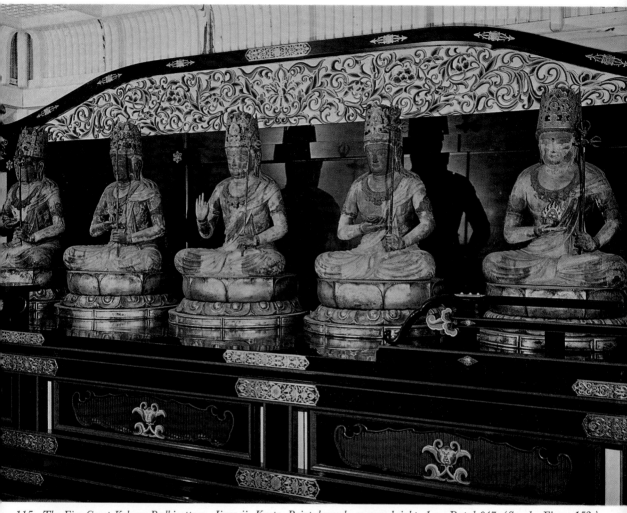

115. The Five Great Kokuzo Bodhisattvas, Jingo-ji, Kyoto. Painted wood; average height, 1 m. Dated 847. (See also Figure 152.)

◁ *114. Interior of ground level of five-storied pagoda, Daigo-ji, Kyoto, showing mandala paintings. The board casing around the central pillar is 261.5 by 70 centimeters to a side. (See also Figure 106.)*

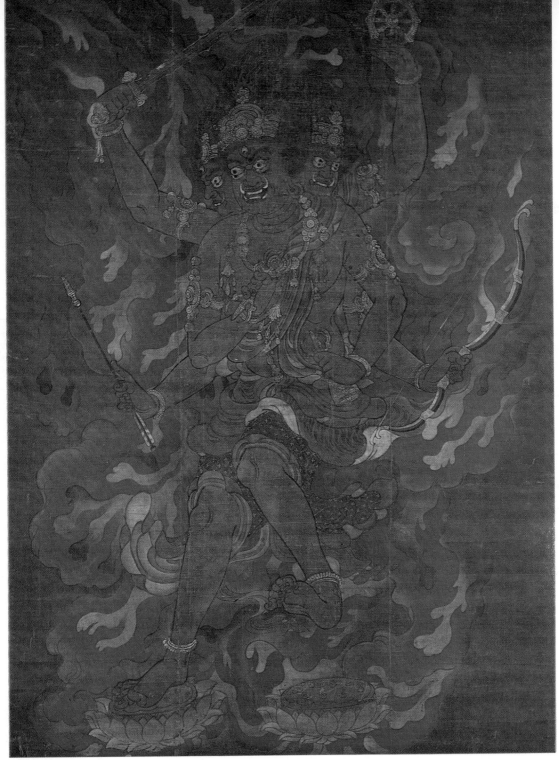

116. *Kongo Yakusha Myo-o, one of the Five Great Kings of Light, Daigo-ji, Kyoto. Colors on silk; height, 179.7 cm.; width, 126.9 cm. Second half of twelfth century.*

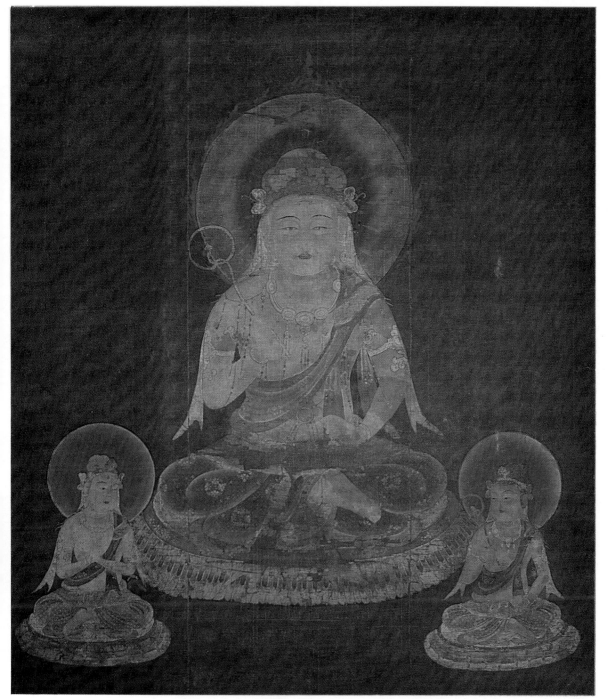

117. Sui Ten, one of the Twelve Celestial Beings, To-ji, Kyoto. Colors on silk; height, 144 cm.; width, 126.5 cm. Dated 1127.

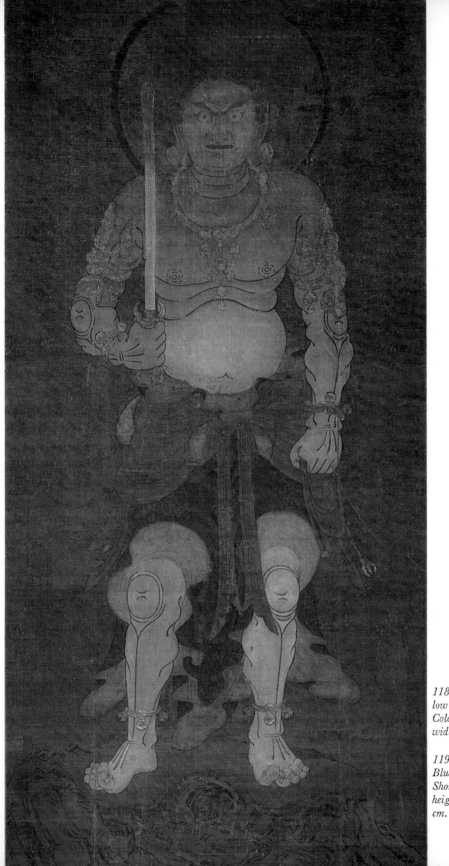

118 (left). Fudo Myo-o (the Yellow Fudo), Manju-in, Kyoto. Colors on silk; height, 178.1 cm.; width, 80.3 cm. Tenth century.

119 (right). Fudo Myo-o (the ▷ Blue Fudo) and doji attendants, Shoren-in, Kyoto. Colors on silk; height, 203.3 cm.; width, 148.8 cm. Second half of eleventh century.

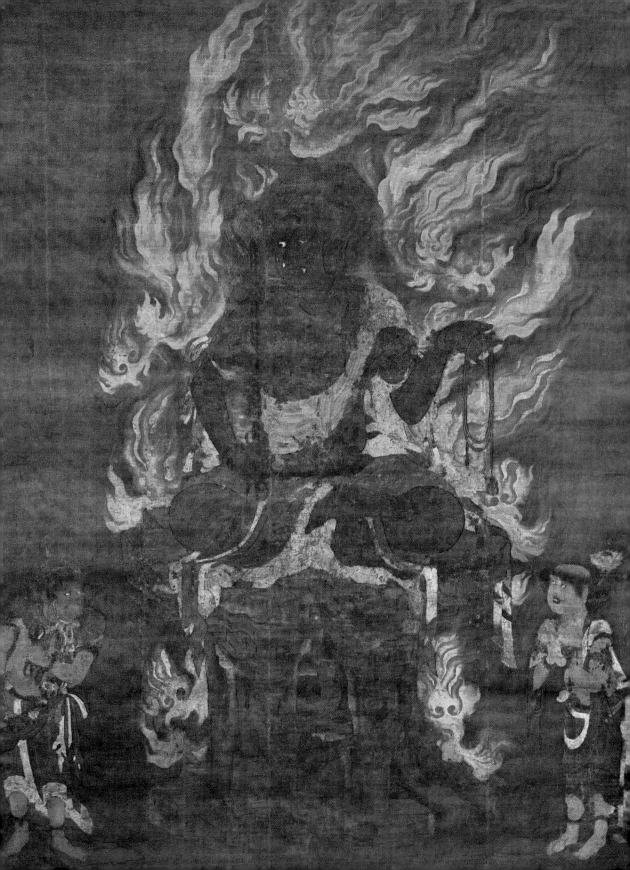

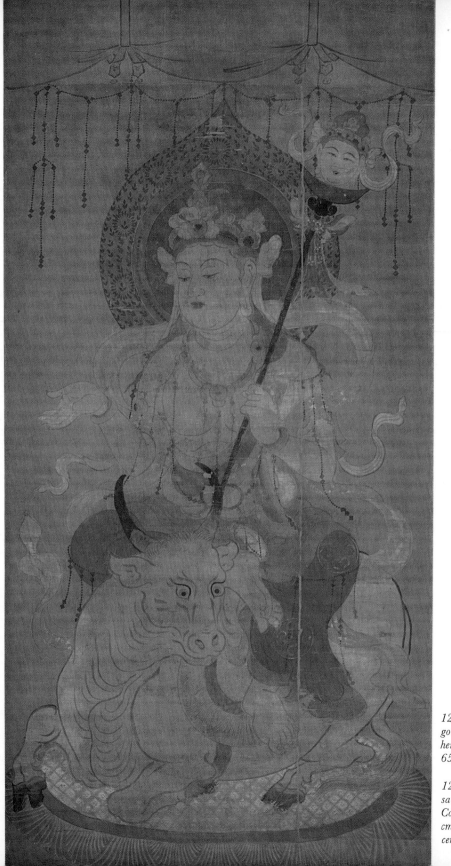

120 (left). Emma Ten, Dai-go-ji, Kyoto. Colors on silk; height, 129.1 cm.; width, 65.4 cm. Twelfth century.

121 (right). Fugen Emmei Bo-satsu, Matsu-no-o-dera, Kyoto. Colors on silk; height, 139 cm.; width, 66.7 cm. Twelfth century.

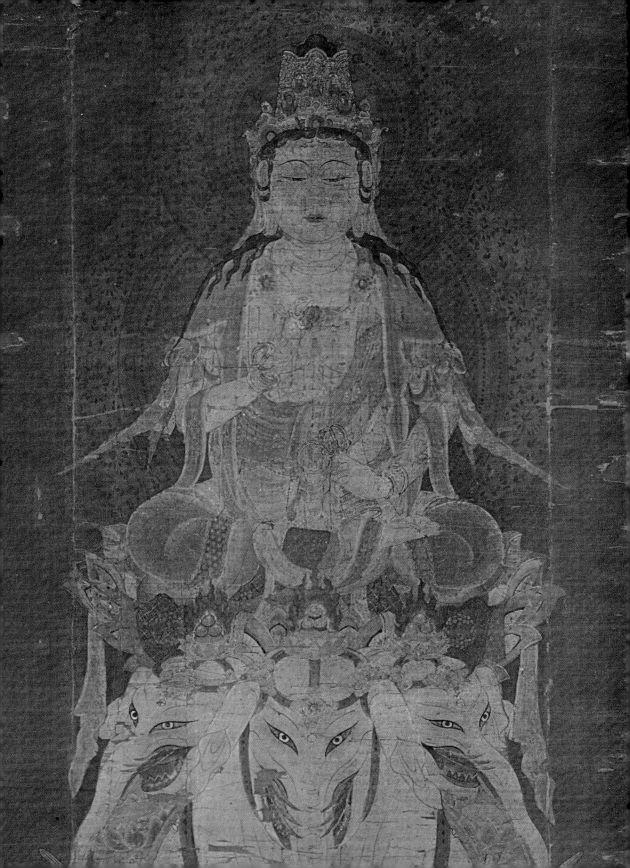

122. Shinto god Hachiman represented as a Buddhist priest, To-ji, Kyoto. Painted wood; height, 109.1 cm. Ninth century.

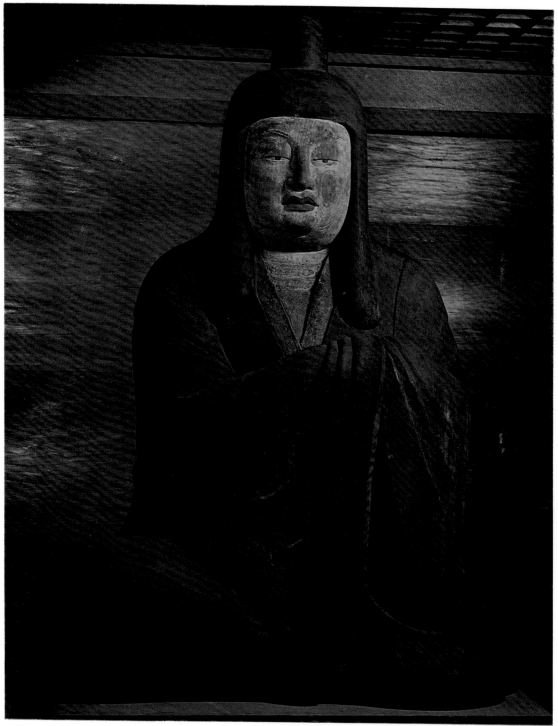

123. *Shinto goddess Fusumi, Kumano Hayatama-jinja, Wakayama Prefecture. Painted wood; height, 98.4 cm. Ninth century.*

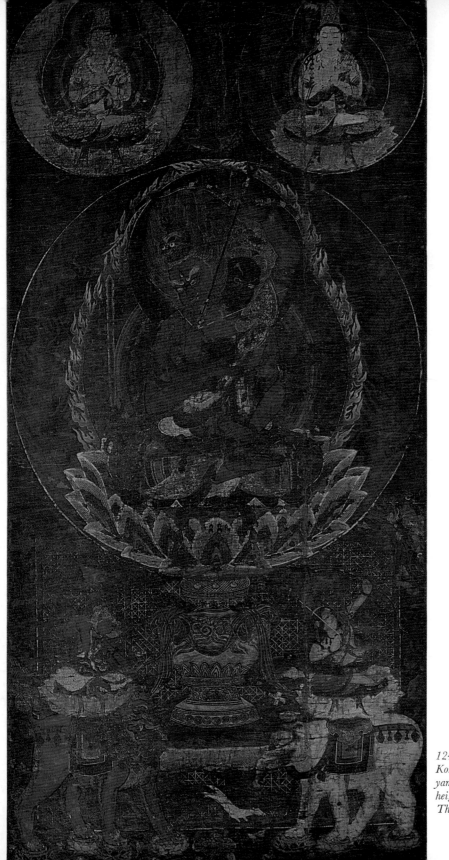

124. *Two-headed Aizen Myo-o,
Kongobu-ji, Mount Koya, Waka-
yama Prefecture. Colors on silk;
height, 118.5 cm.; width, 58 cm.
Thirteenth century.*

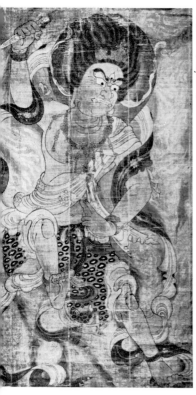

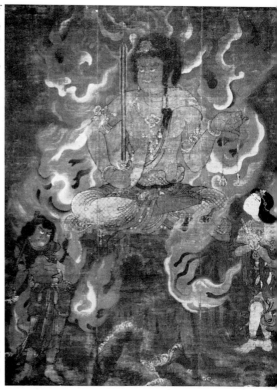

125. *Muijurikiku Bosatsu, one of the Five Mighty Bodhisattvas, Yushi Hachimanko Juhakka-in, Mount Koya, Wakayama Prefecture. Colors on silk; height, 323 cm; width, 179.4 cm. About mid-ninth century.*

126. *Fudo-Myo-o and* doji *attendants, Daigo-ji, Kyoto. Colors on silk; height, 182.7 cm.; width, 136.7 cm. Late twelfth century.*

the Two Worlds at the Jingo-ji. Tendai Esoteric Buddhism, as we have seen, showed a strong aesthetic leaning toward paintings of divinities in forms that may, at least from the Shingon point of view, be considered novel or, at any rate, different from standard forms. In the case of pictures of Fudo, the Tendai influence found its way into many Shingon paintings. A good example of painting in which this influence is displayed is the strongly three-dimensional picture of Fudo among those of the Five Great Kings of Light at the Daigo-ji (Fig. 126). Although the representations rarely strayed too far from the main outlines of the stipulated iconography, there are at least two very interesting and unusual portrayals of Fudo. One of these, dating from 1282 and now at the Daigo-ji, is a painting by Shinkai that may have been designed to conform to prayer rituals peculiar to the Kamakura period. In it, Fudo, standing on a rock in the sea, leans one elbow on the pommel of his sword, the tip of which

rests on the rock. He is looking across the waves at something in the distance (Fig. 108). The other picture, dating from the twelfth century and now in the Atami Art Museum (Shizuoka Prefecture), shows Fudo in what must be a combination of his own attributes and those of Gosanze Myo-o (Trailokyavijaya, Subduer of the Three Worlds), for he has four heads and is treading on Siva and his consort Parvati (Fig. 128). This representation probably derives from a passage in a commentary on the *Dainichi-kyo* to the effect that Fudo and Gosanze are one body.

Fudo is almost always accompanied by attendants known generically as *doji*. Sometimes there are two: Kongara Doji (Kimkara) and Seitaka Doji (Cetaka), as in Figures 13, 119, 126, and 128. Sometimes there are six (the Roku Dai Doji) and sometimes eight (the Hachi Dai Doji). The Kamakura-period statues of Fudo and the Hachi Dai Doji in the Fudodo of the Kongobu-ji are among

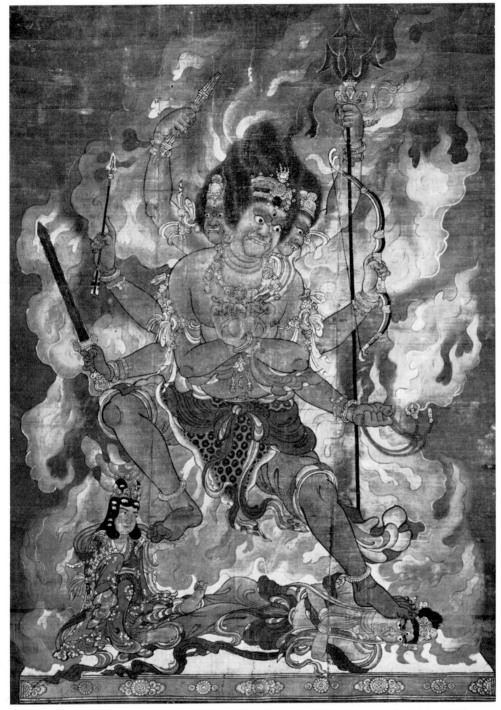

127. Gosanze Myo-o, one of the Five Great Kings of Light, Daigo-ji, Kyoto. Colors on silk; height, 193.9 cm.; width, 126.2 cm. Late twelfth century.

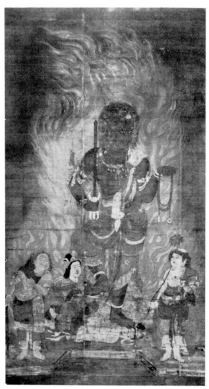

128. Fudo Myo-o trampling on Siva and his consort Parvati, Atami Art Museum, Shizuoka Prefecture. Colors on silk; height, 168.4 cm.; width, 89.2 cm. Late twelfth century.

129. Shinto goddess, To-ji, Kyoto. Painted wood; height of entire statue, 115 cm. Ninth century.

the finest of such representations. The childlike realism of modeling and the beauty of color and decorative design in the figures of the attendants have no peer (Fig. 175). A chronicle known as the *Koya Shunju* attributes this splendid work to the great sculptor Unkei, but there is nothing to prove the claim.

Since the two greatest Esoteric Buddhist monastery-temples in Japan were established on mountains—the Kongobu-ji on Mount Koya and the Enryaku-ji on Mount Hiei—the Shingon and Tendai sects are often referred to as Mountain Buddhism. In fact, however, the history of mountain temples and ascetic training and rituals practiced in mountain fastnesses predates the establishment of these two sects. As early as the primitive period the Jap-

anese people revered mountains as holy places. From the time when Buddhism was introduced in the mid-sixth century until about the middle of the Nara period, devout priests sometimes left the great urban temples to pursue their faith in remote mountain regions where they soon earned the devotion of the common people. Kukai himself selected Mount Koya as the headquarters of the Shingon sect because he believed mountains to be the most suitable environment for the kind of study and training necessary to achieve Buddhahood in this life.

During the Nara period the most widely known retreats of ascetic priests—the places in which many of these men began their life of devotion and preaching—were the Omine Mountains and Mount Ka-

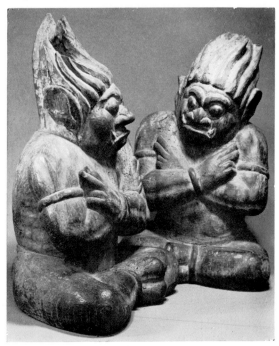

130. *En no Gyoja, Ishiuma-dera, Shiga Prefecture.*
Wood; height, 78.8 cm. Early fourteenth century.

131. *Demon attendants of En no Gyoja, Sainan-in, Taima-*
dera, Nara, Wood; height, 49 cm. each. Fourteenth century.

tsuragi in Nara Prefecture. In the Heian period the importance of these mountains increased until the region became a sacred one for the system of ritual growing up around ascetic and Esoteric practices. There were, of course, many more such mountain retreats, including those on Mount Fuji and in the mountains of Nikko, as well as others even more remote from Kyoto and Nara.

The number of ascetic priests engaged in the propagation of Esoteric Buddhism increased remarkably after the Heian period. Entering the mountain areas that had been objects of popular reverence from time immemorial, these men built small huts for themselves where they lived and taught. Gradually their simple dwellings became temple settlements that more often than not combined the ancient indigenous Shinto elements of worship with Buddhism to become at once temple and shrine. In the Meiji era (1868–1912), however, the Japanese government, eager to shore up the

power and firmly establish the overriding authority of Shinto, which centered on emperor worship, passed a law dictating the separation of Buddhism and Shinto. This legal move generally had one of three effects: the temple and the shrine became independent of each other; the temple retained a small Shinto shrine honoring some primitive deity whose duty it was to protect the temple; or the shrine remained and the temple was destroyed.

The ascetics who founded the above-described temple settlements left behind no written records of their activities, but the scale of their efforts can be estimated from the large number of sculptural. works found in all the regions in which they lived. Using the materials and tools available, they tried to transplant in remote areas as much of the sophisticated culture of the capital as they could. The stone carvings and rough-hewn wooden statues they produced with their own hands scarcely deserve analysis as great works of art; nonetheless, they

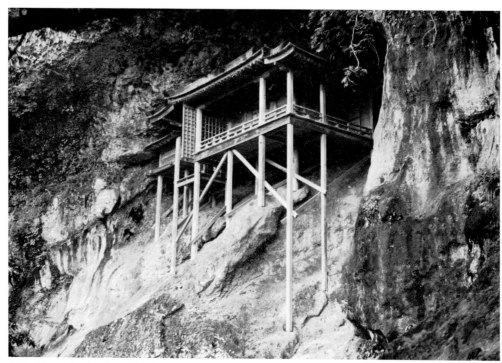

132. *Oku-no-in, Sambutsu-ji, Tottori Prefecture. Frontage, 5.44 m. Second half of eleventh century.*

manifest styles that transcend regionalism. Unfortunately this point has not yet been adequately studied.

Stone carvings of the Buddha appear in Japan as early as the Nara period, but examples of relief groups cut from living rock do not begin until the mid-Heian period. These are almost invariably the works of ascetic priests living in remote areas. A good example of this genre is the stone group found at Usuki, in Oita Prefecture, on the island of Kyushu. Although there are many problems connected with both the date and the chronological order of composition of the figures in this group, stylistic changes apparent in it lead one to think that many years were required in its making. In addition the central Buddha figure suggests that the sculptors were trained in the Tendai tradition of Mount Hiei. Other Heian-period stone reliefs wrought by the hands and primitive tools of the ascetics may be seen at Sugao and other locations in the same pre-

fecture (Figs. 133, 138, 170, 171). On the main island of Honshu similar reliefs occur in Tochigi Prefecture at Oya (Fig. 135), in Toyama Prefecture at the Nisseki-ji (Fig. 68), and in Nara Prefecture in the Jigokudani Shonin Caves (Fig. 136) and the Ishikiri Pass Caves.

In addition to the stone statues and cave reliefs inspired by the teachings of the ascetics, we must take note of the surprisingly large number of wooden statues in which only the flesh areas are finished to a relative smoothness while the remaining details of clothing and other appurtenances clearly show the marks of the chisel and the knife (Figs. 134, 137). The distribution of these statues—most numerous in the northeastern section of Honshu, fairly frequent in the central part of the island, and nonexistent west of the Shiga district (northeast of Kyoto)—suggests that the farther the region was from the capital, the more often ascetic priests made their own statues. For some time, specialists dis-

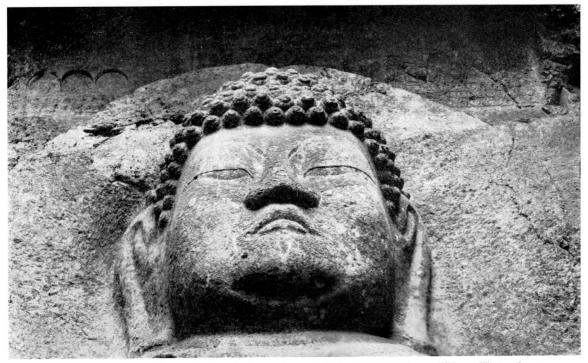

133. *Dainichi Nyorai, Kumano Gongen-sha, Oita Prefecture. Stone relief; height of entire image, 673 cm. Thirteenth century.*

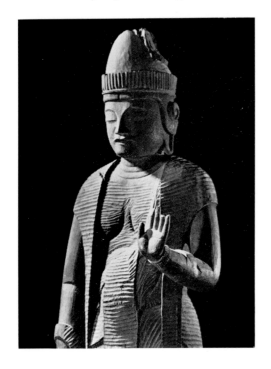

134. *Sho Kannon, Tendai-ji, Iwate Prefecture. Wood; height of entire statue, 118.2 cm. Tenth to eleventh century.*

agreed as to whether the rough surfaces meant that the figures were unfinished or whether the statues were as complete in this form as their creators intended them to be. The rough effect, however, is not used for a deliberately expressive purpose, as it often is in modern sculpture. It merely indicates an abbreviation of details, although, of course, the texture does contribute to the mood of the work. In making their own statues, ascetic priests were only following the teachings of the *Dainichi-kyo*, which states that in order to become a great priest a man must master certain skills. He must be able to paint so as to produce mandalas for himself, and he must know the sculptor's art in order to carve his own statues. Of the great number of such statues, probably carved as a part of priestly training, very few have ever been dealt with in histories of Japanese art, but the subject warrants more attention.

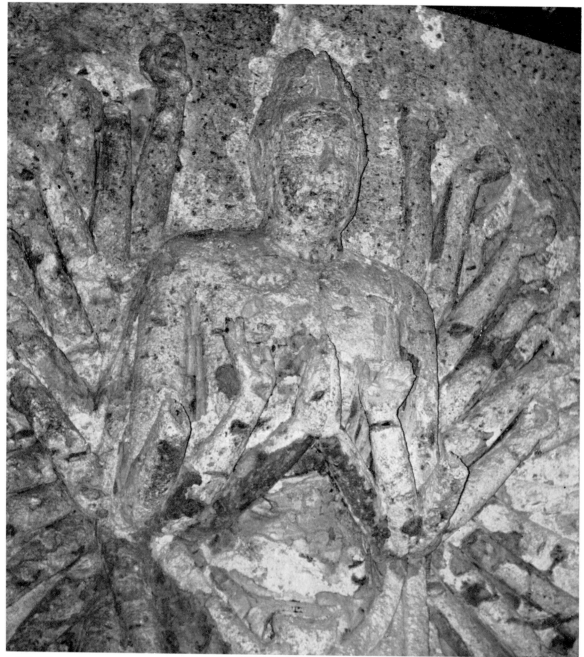

135. *Thousand-armed Kannon, Oya-dera, Tochigi Prefecture. Stone relief; height of entire image, 402 cm. Eleventh to twelfth century.*

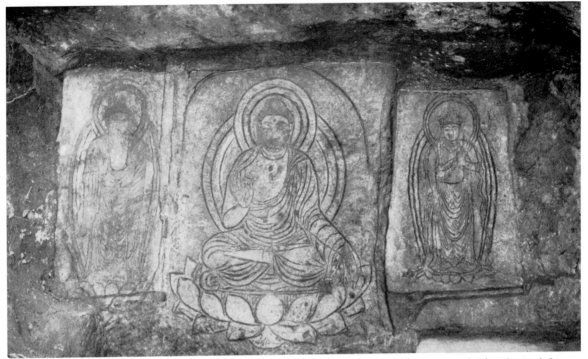

136. A Buddha and attendants, Jigokudani Shonin Caves, Nara Prefecture. Line engraving in stone; height of central figure, 140 cm. Eleventh to twelfth century.

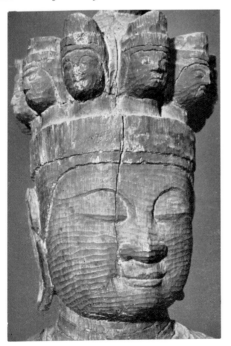

137. Eleven-headed Kannon, Gumyo-ji, Kanagawa Prefecture. Wood; height of entire statue, 181.7 cm. Eleventh century.

Before leaving the works of the diligent and devoted group of unknown ascetic priests, I should like to comment on an unusual genre of statues cut from living trees standing on mountaintops. Although the natural limitations of a single tree trunk confined the sculptors to rectilinear patterns and vertical lines in the main, sometimes bold use was made of the spreading roots on all sides of the base of the tree. The statue of the Thousand-armed Kannon at the Chuzen-ji, in Tochigi Prefecture (Fig. 143), and that of Fudo Myo-o at the Fukuo-ji, in Hiroshima Prefecture (Fig. 142), are good examples of such works. Other statues of Kannon reported to have been carved from living trees exist, but for the sake of preservation most of them have been cut down and moved indoors.

The tradition followed by these priest-sculptors was completely divorced from established styles.

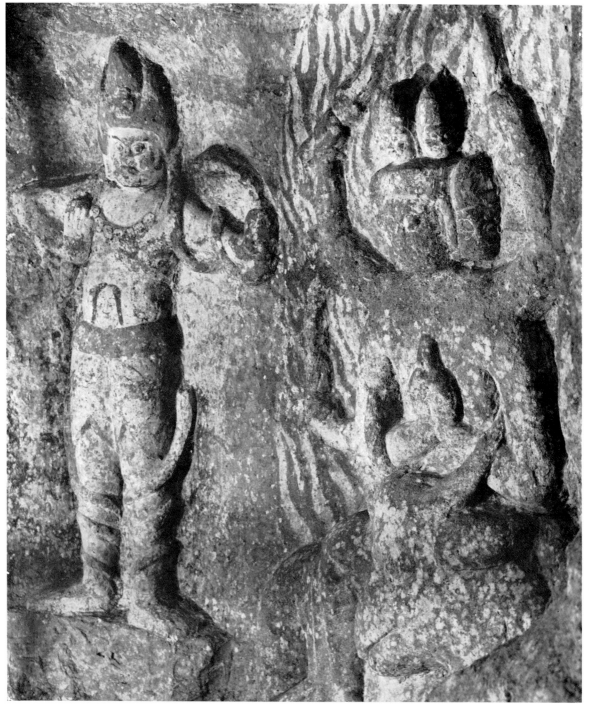

138. *Daiitoku Myo-o, one of the Five Great Kings of Light (right), and guardian general (left), Takase Caves, Oita Prefecture. Stone relief; height of Daiitoku, 139.4 cm. Twelfth century.*

139. *Zao Gongen: fragment of mirror back, Soji-ji, Tokyo. Engraving on bronze; dimensions of fragment, 67 by 76.3 cm. Dated 1001.*

They were loyal to the dictates of their own free spirits in giving sculptural expression to Buddhas and other deities. Perhaps no works so clearly indicate this freedom and the readiness to use any material that came to hand as the statue of Kissho Ten by Mokujiki Shonin, now in the Akoya Bishamon-do, in Hyogo Prefecture (Fig. 141), and that of Zao Gongen by Enku, now in the Kobuchi Kannon-in, in Saitama Prefecture (Fig. 140). Both Mokujiki Shonin and Enku were ascetic priests, and at least Enku is known to have carved statues from living trees.

After Buddhist thought had to some extent filtered through Japanese sensibilities, a number of changes developed in the iconography of various deities. I have already mentioned the changes rung on the single theme of Fudo Myo-o. In some instances, however, the Japanese incorporated into Buddhism divinities that fell completely outside the Buddhist canon. One of the oldest of these adopted gods is the above-mentioned Zao Gongen, whose statue became the central image of the worship derived from the mountain temple at Omine, in Nara Prefecture. Often ferocious in aspect, Zao Gongen usually takes a form that seems to owe much to statues of the Go Dairiki Bosatsu (Five Mighty Bodhisattvas). Judging from his general style and costume, one may assume that his worship dates from the Nara period. A fragment of a mirror back with an engraving of Zao Gongen is dated 1001 (Fig. 139). Other Heian-period representations of this deity are found at the Koryu-ji, in Kyoto, and the Sambutsu-ji, in Tottori (Fig. 166). Zao Gongen lost his high position among the unorthodox Japanese divinities in the late Kamakura period, when it became customary to replace him with statues of the famous Nara-period ascetic priest En no Gyoja (Fig. 130) and accompanying demons (Fig. 131).

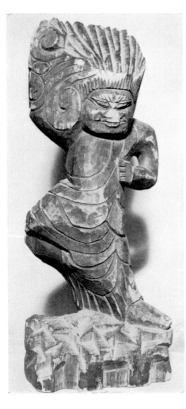

140 (left). Zao Gongen carved by Enku, Kobuchi Kannon-in, Saitama Prefecture. Wood; height of entire statue, 40.3 cm. Dated 1689.

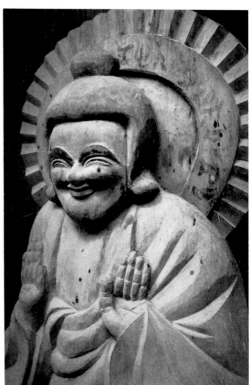

141 (right). Kissho Ten carved by Mokujiki, Akoya Bisha-mondo, Hyogo Prefecture. Wood; height of entire statue, 95.2 cm. Dated 1807.

A combination of the attributes of both Fudo Myo-o and Aizen Myo-o (Ragah) not found in the traditional iconography was often used in figures produced in the style of the Mount Koya Shingon sect. The most beautiful example is a painting in the Kongobu-ji representing the Two-headed Aizen (Fig. 124). Of the numerous other eclectic Buddhist statues produced in especially large numbers after the Muromachi period, few have been carefully researched, and I mention the following ones only in passing: Sambokojin, the Blue-faced Kongo, the grotesque Myogen Bosatsu, and the Tohachi Bishamon Ten.

Perhaps the most significant evidence of the eclecticism of Buddhism in Japan is its relationship with the indigenous Shinto cult. Even in the early Nara period it was not uncommon for people to read the Buddhist sutras in front of shrines to the native Shinto gods during prayers for rain or good harvest. No clear distinction was made between the gods of one religion and those of the other. I have already commented on the generally inclusive nature of Buddhism, which from its inception and early dissemination tended to take into its canon as protective gods the gods of other religions. The same process was followed in Japanese Buddhism: Shinto divinities appeared in new Buddhist garb. The line of thought leading to this phenomenon resembles to a great extent the reasoning that included numerous foreign gods in the mandala as emanations of the Great Sun Buddha Dainichi Nyorai. The native Japanese gods, however, had never been given formal physical representation until they came to occupy a position in the Esoteric canon. It is said that Kukai initiated the belief that Buddhas appear in indigenous forms in certain localities to save mankind. Three very old statues at the To-ji, all dating from the ninth century, seem to substantiate this

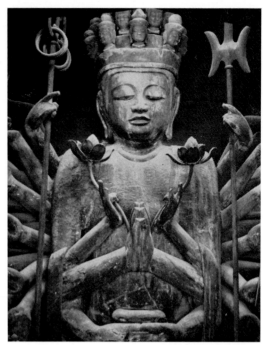

143. Thousand-armed Kannon, Chuzen-ji, Tochigi Prefecture. Originally carved from a living tree; height of entire statue, 535 cm. Twelfth to thirteenth century.

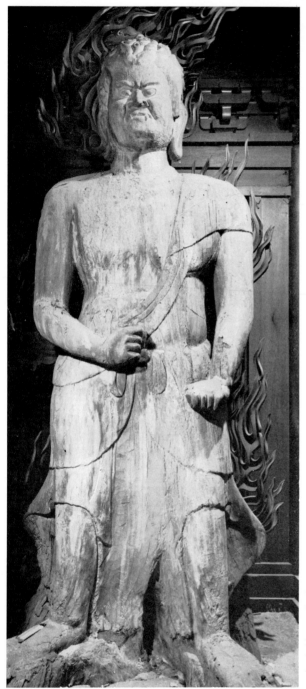

142. Fudo Myo-o, Fukuo-ji, Hiroshima Prefecture. Originally carved from a living tree; height, 308 cm. Twelfth to thirteenth century.

claim, since they are the oldest examples known: the statues of the Shinto god Hachiman personified as a Buddhist priest (Fig. 122) and of two Shinto goddesses (Figs. 129, 165). The generally held opinion is that statues of this kind began to be produced during the Jogan era (859–76), although this date may be a little too early. Some of the most outstanding Shinto statues of the Heian period include those of a god and a goddess (Fig. 146) at the Matsuo Shrine, in Kyoto; two goddesses, one of them personifying the empress Jingo (Fig. 169), and the god Hachiman in the guise of a Buddhist priest (Fig. 168), all at the Yakushi-ji; and, at the Kumano Hayatama Shrine, in Wakayama Prefecture, the goddess Fusumi (Fig. 123) and the god Hayatama no Okami, or Hayatama O no Mikoto (Fig. 144). Interestingly enough, most of the Shinto gods shown in Buddhist-style representations were local deities and not the great central Shinto figures. In

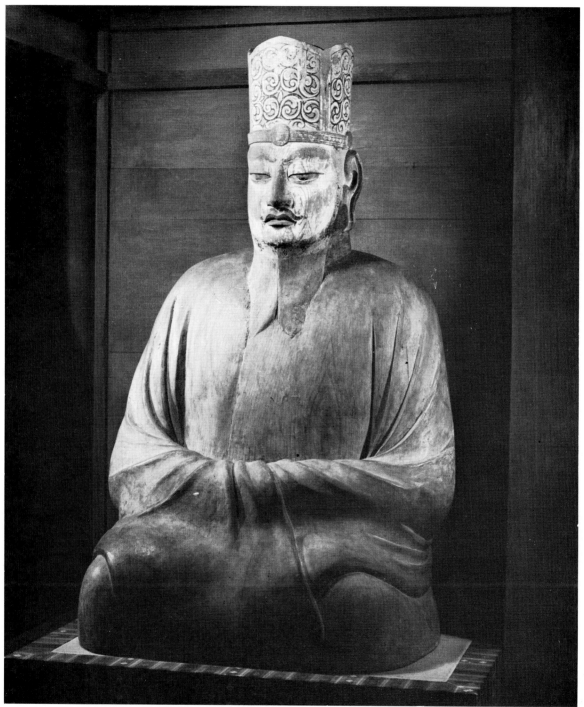

144. Shinto god Hayatama no Okami, Kumano Hayatama-jinja, Wakayama Prefecture. Wood; height, 101.2 cm. Second half of ninth century.

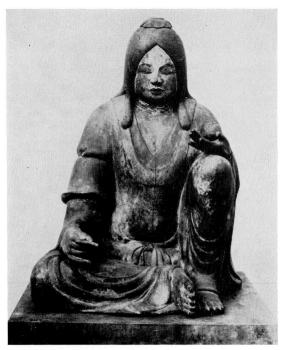

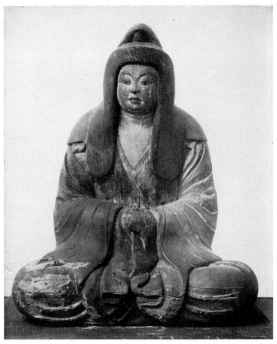

145. Shinto goddess, Kozu-jinja, Shiga Prefecture. Wood; height, 50.3 cm. Ninth to tenth century.

146. Shinto goddess, Matsuo-jinja, Kyoto. Painted wood; height, 86.9 cm. Second half of ninth century.

the later Heian period the number of these statues increased and came to include many rough and simple works carved by ascetics.

The closeness of the connection between Buddhist and Shinto elements of faith is clearly indicated by the fact that in some cases subordinate temples were built in the compounds of Shinto shrines to house Buddhas associated with the shrines, just as small guardian Shinto shrines were built in Buddhist temple compounds to assure divine protection by Shinto divinities. The assistance the two religions offered each other was thus gen-

erally mutual, although there are exceptions to this generality.

Finally I must mention the Shinto-oriented mandalas that were often painted for such great shrines as those of Kasuga (in Nara), Hie (on Mount Hiei), and Kumano (in Kyoto). In such mandalas the deity of the shrine occupies the position of central importance in a compositional pattern that is clearly a variation of the Esoteric Buddhist mandala. The great number and wide variety of these Shinto mandalas clearly testify to their popularity.

Famous Esoteric Temples

WHENEVER ONE FINDS a place in Japan famous for its beautiful scenery, high mountains, rugged and rocky terrain, or hot springs, there is almost always an Esoteric Buddhist temple nearby. Some of these temples date back as far as the Nara period, but most of them originated in the late Heian period, when Esoteric Buddhism enjoyed its greatest popularity. Of course the most important and most renowned of all are the Kongobu-ji on Mount Koya and the Enryaku-ji on Mount Hiei, for it was at these temples that Kukai and Saicho first established their respective sects of Shingon and Tendai. Among the famous Nara-period Esoteric temples, however, I must mention the Daian-ji and the Saidai-ji, both built in Nara when it was the capital. The list of properties of the Saidai-ji includes many Esoteric Buddhist statues, and the Daian-ji, which inherited the doctrine and tradition of the priest Doji Risshi after he returned from a pilgrimage to T'ang China, still possesses several statues of the Esoteric type that were made in the Tempyo, or late Nara, period (710–94). Kukai himself studied at the Daian-ji and employed its traditional teachings in the development of the Shingon sect. There are other Esoteric mountain temples—for example, those at Omine, Miwayama, and Hakusan—but I shall discuss only the most important ones here.

THE KONGOBU-JI After receiving land on Mount Koya from the emperor Saga in 816, Kukai set out to develop a new kind of temple layout in accordance with the precepts of the Shingon sect, which he himself had introduced into Japan. His ambition and his talents were great, but the building of a large temple in a remote and mountainous area was not a task that could be accomplished overnight. Consequently the temple was not finished during his lifetime. The Great Pagoda and the West Pagoda were completed in 887 during the incumbency of Kukai's disciple Shinnen. As we have noted much earlier, the two pagodas, placed at either side of the compound, symbolize the Womb World and the Diamond World, the components of the Mandala of the Two Worlds. Between them are the priests' quarters and in front of these, just inside the inner gate, is the Lecture Hall (today called the Golden Hall) The product of Kukai's own imagination, this plan must have seemed strange to eyes accustomed to the very different Nara-period temple layouts. Indeed, few temples after the Kongobu-ji ever followed this scheme, although a number of them were true to its spirit in that they often housed statues of Dainichi Nyorai and other deities in arrangements symbolic of the Mandala of the Two Worlds. When such arrangements were not feasible, the mandalas were painted or hung on the walls.

In the late Heian and early Kamakura periods the Kongobu-ji enjoyed the reverence and support of the aristocrats of the capital, who did much to build a number of subsidiary temples around it, but today buildings dating from that age are limited

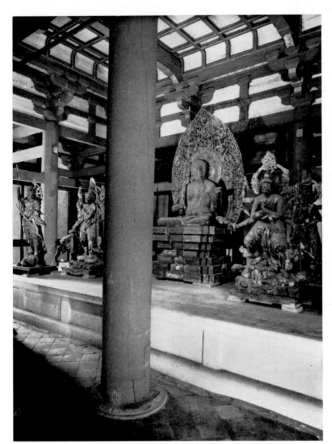

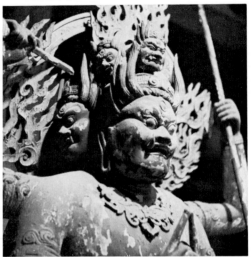

147. *Interior of Lecture Hall, To-ji, Kyoto. (See also Figure 64.)*

148. *Daiitoku Myo-o, one of the Five Great Kings of Light, Lecture Hall, To-ji, Kyoto. Painted wood; height of entire statue, 144 cm. About 839. (See also Figure 77.)*

149 (below). *Placement of statues in Lecture Hall, To-ji, Kyoto. Double circles indicate the Shitenno, or Four Celestial Guardians.*

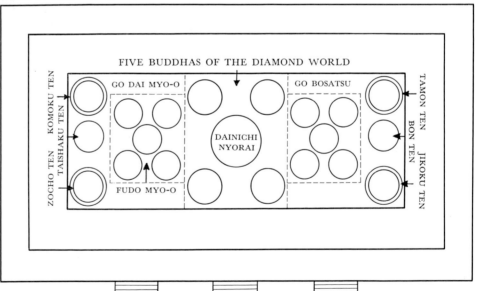

FIVE BUDDHAS OF THE DIAMOND WORLD

KOMOKU TEN
ZOCHO TEN TAISHAKU TEN

GO DAI MYO-O

GO BOSATSU

TAMON TEN
JIKOKU TEN BON TEN

DAINICHI NYORAI

FUDO MYO-O

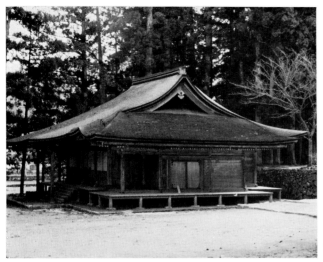

150. Fudodo, Kongobu-ji, Mount Koya, Wakayama Prefecture. Dated 1197.

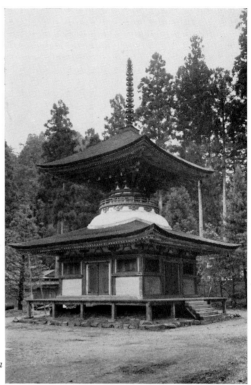

151. Two-storied pagoda, Kongosammai-in, Mount Koya, Wakayama Prefecture. Dated 1223.

to the Fudodo of the Kongobu-ji (Fig. 150), built in 1197, and the two-storied pagoda (Fig. 151) and the Kyozo (Sutra Repository) of the Kongosammai-in, both of which date from 1223. Nevertheless, numerous statues from the late Heian and early Kamakura periods remain in the Kongobu-ji.

From around the end of the Heian period, when the country became involved in political turmoil and internal strife, priests of noble lineage, ascetics, and others of the Buddhist faithful fled to Mount Koya to escape persecution, bringing with them their faith in Amida Nyorai, the Buddha of Boundless Light, and thus establishing the Amidist tradition there. It is no doubt for this reason that one finds many statues of Amida Nyorai in the temples of Mount Koya today. At this time also, there began the activities of the so-called sages of Mount Koya, who were to spread the fame of the mountain throughout the entire nation and to bring back

with them countless valuable articles that remain there today as priceless cultural properties.

As we have already observed, the combined Indian and Esoteric style of the lost statues once housed in the Kongobu-ji Lecture Hall is reflected in the Dainichi Nyorai of the West Pagoda. It is also to be seen in the Dainichi Nyorai now kept in the Mount Koya Reihokan, or Gallery of Treasures, and in various other statues, but this art style never blossomed into a true Mount Koya style. In fact, we must view the art of Mount Koya after the Heian period as a miscellany of works of varying lineage. Among those of surpassing excellence, many were brought here by unknown persons in post-Heian times. For example, the paintings of the Five Mighty Bodhisattvas owned by the Yushi Hachimanko Juhakka-in (Figs. 12, 125), the Red Fudo in the Myo-o-in (Fig. 13), and other works came from the To-ji, while the famous painting of

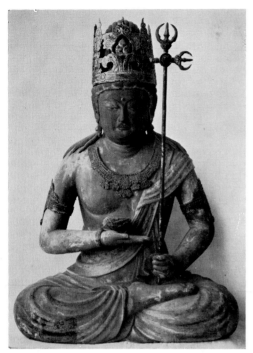

152. Renge Kokuzo Bosatsu, one of the five emanations of Kokuzo Bosatsu, Jingo-ji, Kyoto. Painted wood; height, 99.7 cm. Dated 847. (See also Figure 115.)

153. Female deity of the Diamond World: detail from Diamond World section of Mandala of the Two Worlds, Jingo-ji, Kyoto. Gold and silver on patterned purple silk. About 831.

Amida and twenty-five Bodhisattvas descending from paradise to welcome a dying believer—a work representing the art of the Jodo (Pure Land) Sect—came from Mount Hiei.

THE TO-JI The other great temple associated with Kukai—the To-ji, or Kyo-o-gokoku-ji—was one of two that were to be built on the east and west sides of the south gate, or Rasho-mon, to the city of Kyoto (then called Heian-kyo). These temples were intended to invoke the protection of the divinities and thereby to assure the peace and prosperity of the city. Since the Kyo-o-gokoku-ji was built on the east (*to*) side of the gate, it became popularly known as the To-ji, or East Temple. Even today its massive buildings, tile-topped clay walls, and soaring pagoda evoke an image of the capital as it was in the ancient past.

Reminiscent of the plans employed in Nara temples, the layout of the To-ji (Fig. 65) centers on a north-south axis along which are placed the inner gate, the Golden Hall, the Lecture Hall, and the Refectory. The single pagoda rises in the southeast corner of the plot. In general, the plan is very much like that of the Kofuku-ji, which was built in Nara early in the eighth century.

The To-ji was part of the total plan of the new capital, established in 794 on the site of modern Kyoto when it was felt imperative, for a variety of reasons, to abandon the older capital at Nara. Kukai was placed in charge of the To-ji in 823 and thereafter conducted all further planning and building. Although the general layout is conservative, Kukai housed many Esoteric statues in the buildings and even added other buildings to suit the needs of Shingon worship.

The outstanding Esoteric elements in the temple's treasury of art are merely summarized here, since the majority of them have been discussed earlier in the book. The Golden Hall contains statues of Yakushi Nyorai and the Twelve Godly Generals. The pagoda, instead of being a reliquary, as had been the custom in the Nara period, is a symbolization of the Mandala of the Two Worlds. The Lecture Hall is ornamented with a brilliant collection of statues centering on the Five Buddhas of the Diamond World and incorporating Bodhisattvas, Myo-o, and other divine beings in a placement based on Kukai's religious beliefs and on the precepts of the *Sutra of Benevolent Kings* (Ninno-kyo). The Mieido contains a statue of Fudo Myo-o that is traditionally thought to have played an important part in Kukai's personal devotions. Finally, in the Refectory there is a handsome Chinese T'ang-dynasty statue of the Tobatsu (Helmeted) Bishamon Ten (Fig. 154) which was originally housed in the superstructure of the now vanished Rashomon gate. Since Bishamon Ten offered protection from the dangers of the north, an especially ill-omened direction, he was often represented in sculpture but seldom with the excellence displayed by the To-ji work.

After its foundation, the To-ji, as the central temple of the Shingon sect, was managed by the two leading branches of that sect: the Hirosawa (or Ninna-ji) branch and the Ono (or Daigo-ji) branch. But in the late Kamakura period (fourteenth century), as it became increasingly popular to worship Kukai himself, the temple gradually became independent. The basis for its economic freedom was firmly established in the Muromachi period. Today the many important cultural properties and priceless works of Heian-period art housed at the To-ji bear clear witness to its importance both to Shingon Buddhism and to the religious development of the entire nation.

THE JINGO-JI Standing high on a cliff on Mount Takao in the rugged northwestern district of Kyoto and overlooking the Kiyotaki River, the Jingo-ji and its associated temples control an important section of land rich in

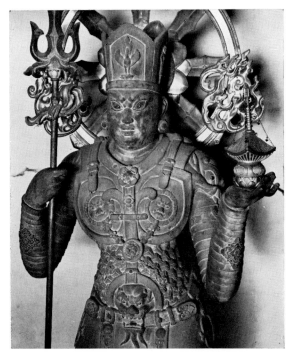

154. *Tobatsu Bishamon Ten, Refectory, To-ji, Kyoto. Wood; height of entire statue, 194 cm. Ninth century.*

fresh spring greenery and dazzling autumn foliage of maples—and once strategically vital because a road leading from Kyoto to the surrounding mountains passes through it. Although the origins of the temple are uncertain, it is known that it was once called the Jingan-ji and that one Wake no Kiyomaro, a court official who played a part in the establishment of the new capital at Kyoto, was buried there in 799. Saicho taught and preached at this temple after his return from T'ang China, but after 809, when Kukai came home from China and began instruction in the beliefs and concepts of the Shingon sect, the Jingo-ji became closely associated with him. In 816, its name was changed to the Jingo Kobuso Shingon-ji, and in 829 it was officially entrusted to Kukai. From that time to the present, it has been a Shingon temple. According to records preserved at the temple, in addition to

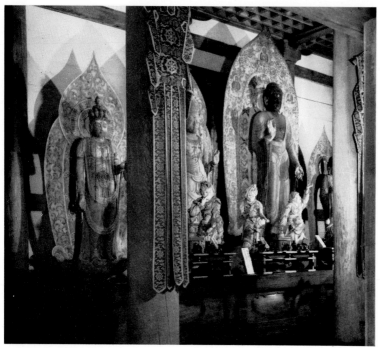

155. *Interior of Golden Hall, Muro-ji, Nara Prefecture. Height of central figure (Shaka Nyorai, at right), 238 cm.*

the Kondo, or Main Hall, the compound formerly included an Anointment Hall and a Worship Hall. Later a Treasure Pagoda was added to house images of the five emanations of the Kobuzo Bodhisattva. Most outstanding among the temple's works of Esoteric Buddhist art are the statue of Yakushi Nyorai (Figs. 27, 84), the Five Great Kokuzo Bodhisattvas (Figs. 86, 115, 152), and a Mandala of the Two Worlds painted in silver and gold on a purple ground (Figs. 103, 153).

The Yakushi Nyorai, thought to have been made in 802, follows a style prevalent before the full-scale introduction of Esoteric Buddhist ideas but adds to that style a sense of physical volume and a sternness of facial expression that suggests a religious approach close to the one later formally expounded in Shingon and Tendai doctrines. In this sense, although the statue itself falls outside the true Esoteric stream, it can be called Esoteric-style art.

Since I have already taken note of the similarities and differences between the Five Kobuzo Bodhisattvas at the Jingo-ji and the Nyoirin Kannon at the Kanshin-ji, it will be sufficient to remark here that the Kokuzo statues, strongly influenced by the sculptural style of the Enryaku-ji, embody a new development based on older tradition. The dates of the production of these statues and that of the Nyoirin Kannon further substantiate this assumption: the Kanshin-ji statue was made around 836 and the Kokuzo statues in 847.

Already in the Heian period the Jingo-ji mandala in gold and silver paint was revered as a work from the hands of the great Kukai himself, and copies of its individual figures were therefore often made. A tradition to the effect that the mandala was painted in 831 appears to make it the oldest extant one representing the Shingon faith. Although some of the figures in the mandala have

been distinctly Sinicized in the T'ang manner, most of them are characterized by a general fleshiness suggesting strong Indian influence (Figs. 103, 153, 162). The mandala is now badly damaged and has been much touched up by later hands, but an easy flow of line is still apparent.

THE MURO-JI Some distance from the city of Nara is the small village of Muro, site of the Muro-ji. One reaches Muro by following a winding, climbing road along a river, and the temple stands at the foot of the hills that lie across the river from the village proper. A rather literary, poetic mood, similar to that which pervades mountaintop temples, dominates the whole scene. No exact information about the founding of the Muro-ji exists, but it seems entirely likely that some mountain ascetic of the distant past first built the temple in association with the Shinto shrine Ryuketsu-jinja, located about two hundred meters upstream. In a word, the temple appears to have developed against a background of the characteristic Japanese eclectic attitude toward religion.

The Muro-ji has belonged to a number of different sects throughout its long history. The details of the many changes it has undergone are not known for certain, but it seems that it was once under the sway of the great Kofuku-ji in Nara and that it was extremely wealthy and powerful during the Heian period. This is not surprising, since the Kofuku-ji was intimately associated with the Fujiwara clan, whose fortunes were at their zenith in Heian times. The similarity between the placement of the statues in the Golden Hall of the Muro-ji and that of the statues of Shinto-incorporated Buddhas at the Kasuga Shrine—the tutelary shrine of the Fujiwara—strengthens the likelihood of a relationship between the Muro-ji and the Kofuku-ji. Shingon elements seem to have pervaded the Muro-ji in the late Heian period and to have persisted for some time in conjunction with the older faith derived from the Kofuku-ji. In the Edo period (1603–1868) the Muro-ji was officially designated a Shingon temple.

Artistically, the most important building at the Muro-ji is the Golden Hall (Figs. 155, 157), which

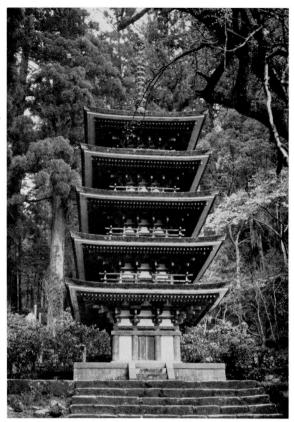

156. Five-storied pagoda, Muro-ji, Nara Prefecture. Height, 16.2 m. Late eighth to early ninth century.

157. Golden Hall, Muro-ji, Nara Prefecture. Area, 12 m. by 12 m. Ninth century.

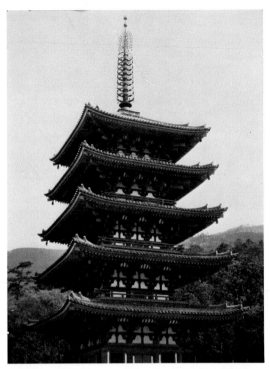

158. *Five-storied pagoda, Daigo-ji, Kyoto. Completed in 951.*

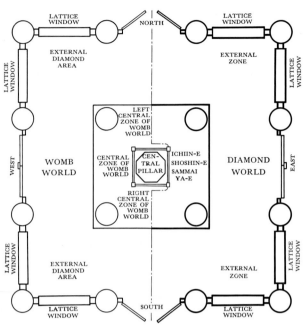

159. *Plan of representation of Mandala of the Two Worlds in five-storied pagoda, Daigo-ji, Kyoto.*

houses such statues as those of Shaka Nyorai, Yaku-shi Nyorai, the Bodhisattvas Monju (Manjusri) and Jizo (Ksitigarbha), the Eleven-headed Kannon, and the Twelve Godly Generals. The statues are not all of the same period, and there are a number of problems connected with them.

Behind the central figure among the statues, the Shaka Nyorai, is a mural painting of the Mandala of the Womb World, generally hidden by the statuary but of great interest because of its unusual features (Fig. 40). The central trinity of the mandala and all the smaller surrounding figures are pictured in the customary form of dwellers in paradise, but the mandala itself is virtually unique. First of all, although it is known as the Taishaku Ten Mandala, there are no characteristics in the painting to lead to certain identification of the central figure as that of Taishaku Ten. Furthermore, no documentation exists to substantiate such an

identification. Again, it is impossible to equate the figure with the god worshiped at the Ryuketsu Shrine, thought to be associated with the Muro-ji. All that can be said about this mandala is that it probably represents some specialized faith considered important by the founders of the temple. Although it roughly approximates the Mandala of the Womb World in form, the so-called Taishaku Ten Mandala is both abbreviated and primitive.

The other buildings at the Muro-ji, including the famous five-storied pagoda (Fig. 156), the Anoint-ment Hall, and the Miroku (Maitreya) Hall, follow no regular pattern of placement. Unlike the Kongo-bu-ji, where definite religious ideas were expressed by the positioning of the buildings within the complex, mountain temples of the type usually originated and managed by ascetic priests developed gradually and thus rarely adhered to any total plot plan. It does not follow, however, that temples as-

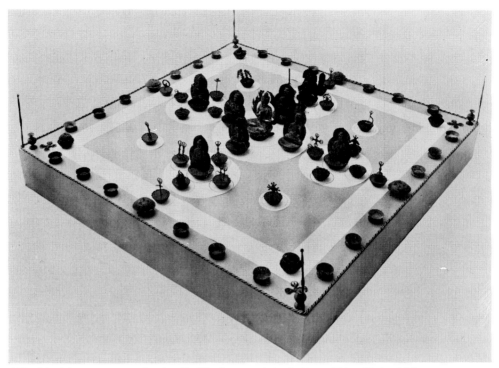

160. Mandala arrangement of ancient Buddha figures and ritual objects, Tokyo National Museum.

sociated with Esoteric Buddhism never have a planned layout, for, as we have already noted, the Kongobu-ji itself refutes this often-advanced but mistaken assumption.

Last of all, in speaking of the Muro-ji, I must mention the six-armed statue of the Nyoirin Kannon kept in the Anointment Hall (Fig. 174). Though interesting in a number of ways, it is of a stylized kind often produced during the late Heian period.

THE DAIGO-JI In 874, the priest Shobo, who had studied Exoteric Buddhism in Nara and Esoteric Buddhism under the priest Shinga, built a small hermitage on top of Mount Kasatori, south of Kyoto, and there enshrined images of the Juntei Kannon and the Nyoirin Kannon. This marked the beginning of the Daigo-ji. Between 901 and 921, the Yakushido, the Godaido

(Hall of the Five Great Kings of Light), and other buildings were constructed, thus substantially completing the upper precinct of the temple as it exists today. During the same two decades, at the foot of Mount Kasatori, the construction of such buildings as the Shakado (Hall of Shaka Nyorai) and the Sammaido (a hall for study and concentration) got under way, and in 951, with the completion of the five-storied pagoda (Figs. 158, 159), the lower level achieved more or less its final form. The upper level, like the Muro-ji, follows no definite layout plan, but the placement of buildings in the lower level resembles that of the To-ji: the Great South Gate, the five-storied pagoda in the southeast corner of the site, an inner gate, and the Golden Hall, all aligned along a central axis.

The Daigo-ji became the headquarters of the Ono branch of Shingon Buddhism. It also developed close ties with the ascetic adherents of the

Omine faith, which, as we have noted, had its origins in the mountains of that name. Consequently, many regional temples associated with this faith came under the control of the Daigo-ji. Again, as a center of Esoteric teaching, the temple developed extensive ties with the aristocracy of the capital, who endowed it with many important cultural properties. Since Esoteric teaching was energetically carried out at the Daigo-ji, the temple came to possess a large number of works of art and literature, many of which still survive. Among its treasures are a number of *hakubyo no zu*—ink paintings of a genre peculiar to Esoteric Buddhism—and three paintings by Shinkai, son of the powerful nobleman Fujiwara Nobuzane, among which the most famous is the one of Fudo Myo-o (Fig. 108). In fact, no other temple in Japan owns as many Esoteric paintings as the Daigo-ji.

THE ENRYAKU-JI When Saicho founded his temple on Mount Hiei in 788, he called it the Ichijo Shikan-in, but in 823, when it became the most important institution in Tendai Buddhism, the name was changed to Enryaku-ji. During Saicho's lifetime no distinctly Esoteric practices were followed at the Enryaku-ji, and the main object of worship was Yakushi Nyorai, whose image is presently enshrined in the Komponchudo (Main Hall) of the temple. It was not until the time of Gishin, who assumed leadership of the temple in 824, and Ennin, who returned from T'ang China in 847, that the Esoteric nature of worship at the Enryaku-ji became pronounced. It was under their dispensation that such statues as

those of Dainichi Nyorai, the Eleven-headed Kannon, the Thousand-armed Kannon, and Fudo Myo-o were commissioned, although the temple complex itself had not yet taken on a characteristically Tendai Esoteric quality. Only the present Komponchudo, in its division into inner and outer precincts, displayed an Esoteric coloration at that time.

THE ONJO-JI The Onjo-ji is said to have been founded in 686 by an imperial prince, son of the emperor Kobun. At that time it bore the name Mii-dera (Imperial Well Temple), and it is still often referred to by that name today, although the characters with which the name is presently written have the literal meaning of Three Wells Temple. The temple came to full flower as an Esoteric institution under the priest Enchin, who restored it in 858 and gave it the name Onjo-ji. Enchin brought with him from China a large number of Esoteric materials differing from those introduced earlier by Kukai, and he used them in the development of a version of the Tendai sect that was largely critical of Shingon. The paintings, statues, and mandalas that played a vital part in Enchin's Tendai worship often strayed from established orthodoxy, as we have already noted in the case of the famous Yellow Fudo. The Onjo-ji trained many outstanding artists and in the late Heian period developed close connections with regional temples in the Kumano area, in Wakayama Prefecture, and in this way facilitated the spread of Tendai teaching to more remote parts of the country.

CHAPTER SEVEN

The World of the Mandala

WE HAVE ALREADY taken note of the mandala as an art form, but it may be of some additional value to look a bit more closely at its religious and philosophical connotations. Such an examination, though necessarily brief, will reveal the features that give interest to the mandala as an expression of Esoteric Buddhist concepts.

Though Buddhist dictionaries list many other associated meanings of the word, in general, when one speaks of a mandala, one means a painted or sculptured representation of the universe in which Dainichi Nyorai presides as the greatest of all Buddhas. Surrounding him are other Buddhas, Bodhisattvas, Myo-o, Ten, and similar divinities, all of whom are emanations of himself. Thus the mandala symbolizes both the overwhelming creative strength of Dainichi and the power of all those beings who emanate from him. In short, it is a representation of the ideal Esoteric Buddhist universe.

According to instructions in the sutras, followers of Esoteric teachings are required to build altars for worship and to paint on the altar tops representations of the ideal universe. In other words, the altar is incomplete until it bears a mandala. To be sure, "altar" is one of the translations given for the word "mandala" in Buddhist dictionaries. Another translation, "place of religious training," further emphasizes the importance of the mandala in Esoteric worship.

It will be helpful to repeat briefly here the distinctions in composition between the Mandala of

the Womb World and the Mandala of the Diamond World. The former is essentially a pattern of concentric squares. The central square encloses an eight-petaled lotus blossom in the heart of which sits Dainichi Nyorai. On each of the eight petals sits another Buddha. These nine figures are larger than the almost countless Bodhisattvas, Myo-o, and other divinities ranked around them, and the sizes of the subordinate figures decrease from the center to the periphery of the mandala. The Mandala of the Diamond World, on the other hand, consists of nine small mandalas, all of equal size, arranged in three rows of three each. The pattern in each of the small mandalas is a combination of circles and squares, and, except for the figures in the top three squares, no distinction is made in the size of the divinities. Little is known about the process by which two quite different types of composition came into being, although the Womb World arrangement seems to be the older.

It is clear, however, that the differences between the two mandalas result from the different sutras on which they are based. The Mandala of the Womb World is a pictorial representation of teachings set down in the *Dainichi-kyo* (Vairocana Sutra), thought to have been compiled in the seventh century in western India. The Mandala of the Diamond World is based on the *Kongocho-kyo* (Diamond Crown Sutra), which is believed to have been composed in southeastern India at about the same time as the *Dainichi-kyo*. Despite their dissimilarities, the

161. *Ritual objects of Esoteric Buddhism, Itsu-kushima-jinja, Hiroshima Prefecture. Gold-plated bronze. The bell in the center is surrounded by various forms of the* vajra.

two mandalas deal with the same ideas, and in both Dainichi Nyorai is the central Buddha, the source of all other beings. After his studies in T'ang China, Kukai came to treat the two sutras as a pair that could be joined in the teachings of his Shingon sect.

Variations occurring in both mandalas depend on a number of things. One famous version presents the Mandala of the Womb World in a form that predates Kukai's return from China. Furthermore, mandalas brought to Japan from China after Kukai's time frequently differ in detail. One interesting instance is the *Gobu Shinkan* (Fig. 95), a version of the Mandala of the Diamond World brought to Japan by Enchin. This version, based on a Sanskrit sutra never translated into Chinese, was never copied in either China or Japan. In general, the Mandala of the Diamond World tended to remain more constant, whereas the Mandala of the Womb World manifested numerous changes in content as Esoteric Buddhist teachings developed and altered over the ages. The positions of the hands of Dai-

nichi Nyorai—his *mudras*—are different in the two mandalas. In the Mandala of the Womb World his hands assume the *mudra* symbolizing seated meditation (Figs. 41, 100, 102), but in the Mandala of the Diamond World they are in the *mudra* representative of spiritual action and will (Figs. 14, 39).

In the Shingon sect of Esoteric Buddhism, even in temples where some other deity than Dainichi Nyorai is the main object of worship, the two mandalas still form part of the background. For example, although the central image in the Main Hall of the Kanshin-ji is the Nyoirin Kannon (which is usually kept in concealment), the altar in the inner sanctuary is flanked by representations of the mandalas (Figs. 7, 10). At the same time, all mandalas do not necessarily center on Dainichi Nyorai, for any of the Buddhas and other deities who emanate from him can become the centers of mandalas in which they are then surrounded by their subordinates. Sutras and other venerable writings mention the possibility of producing small-

162, 163. *Rishue section of Diamond World from Mandala of the Two Worlds, Jingo-ji, Kyoto (162), and To-ji, Kyoto (163). In this section of the mandala the central figure, Kongo Satta, is surrounded by symbolic representations of human passions.*

world mandalas around deities of lesser grandeur than Dainichi. Since these small-world mandalas occur in forms reminiscent of the Womb World and the Diamond World mandalas, it would seem that they too evolved from different sutras. It should be pointed out, however, that the influence of the Mandala of the Diamond World on the composition and selection of gods to be depicted in the Mandala of the Womb World was especially noticeable in Japan. No doubt this development resulted from the greater emphasis placed on the Diamond World by Shingon thought. It should also be noted that the arrangement of the mandala is reflected in temple and monastery layouts, interior plans of main halls, and precedences in rituals, as well as in painting and sculpture.

Before leaving the subject of the mandala, I must say a few words about its representation on the tops of the square altars indispensable to all Esoteric Buddhist worship halls. To be strictly orthodox, the worshiper must draw a mandala on the altar top or arrange statues of the various Buddhas and other divinities there in their exact mandala-style placement (Fig. 160). In general practice, however, a prepared mandala on cloth is usually spread on the altar. In addition to statues and pictures, a number of articles of ritual furniture, each designed to cleanse the worshipers' hearts and purge them of all evil, adorn the altar. There are a bell and a *vajra*, the latter descended from the all-powerful thunderbolt held by Taishaku Ten (Indra) and capable of working great miracles (Fig. 161). There are also spears with three, five, and nine prongs— weapons believed to be of great efficacy. Pictures of Kukai sometimes show him holding one of the five-pronged spears in his right hand.

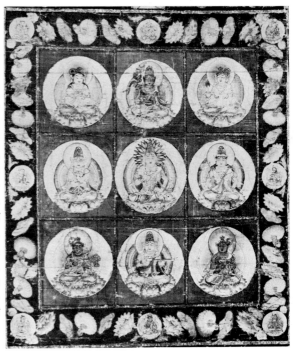

CHAPTER EIGHT

Some Aspects
of Esoteric Deities

ALTHOUGH SOME OF THE information in this chapter is presented by way of recapitulation, it will perhaps be of interest here to develop a bit more thoroughly the theme of deities in the Esoteric pantheon who, for one reason or another, attract particular attention. Both the aesthetic and the religious connotations of their representation in painting and sculpture will be considered in the following brief discussion.

SHINTO GODS IN THE ESOTERIC PANTHEON At a very early date, a blending and intermingling was already taking place between the indigenous Shinto gods and the deities of Buddhism. By the late Nara period (eighth century) many of the Shinto divinities had been designated Bodhisattvas—for example, in a document of 798 mention is made of the "great Bodhisattva Hachiman." Hachiman is a Shinto god of war. Kukai is said to have been responsible for spreading the concept that the Shinto gods were Buddhas in altered form. If (his reasoning went) Dainichi Nyorai is mighty enough to have given birth to all the gods borrowed by Buddhism from the Hindu faith, he is the source of all the Japanese gods as well. Esoteric Buddhist teachings brought many of the Shinto gods into the fold of orthodox respectability and gave them special

titles like Myojin and Gongen. Deities bearing such appellations often attained great popularity. It was only as the interrelations between the Buddhist divinities and those of Shinto became more intimate that the latter were given artistic representation.

The practice of representing Shinto gods in sculpture did not arise from Shinto itself but only emerged after certain shrines developed close ties with Buddhist temples. That is to say, giving concrete form to a divinity for the sake of worship is not a conception inherent in Shinto. Until recently the statue of a goddess in the possession of the Matsuo Shrine (Kyoto) was believed to be the oldest such work in Japan (Fig. 146). This shrine, originally established by the Hata clan, is known to have had connections with Buddhism, as is evidenced by the neighboring mountain temple. The carving of the goddess figure is deep, and the general style is characterized by a sense of volume suggesting that it belongs to a tradition later than that of the Tempyo (late Nara) period, from which it was once thought to date. In fact, it is now generally considered to date from the Jogan era (859–76).

Other statues recently discovered in the Mieido of the To-ji display an entirely different style. One of these images represents the god Hachiman as a Buddhist priest (Fig. 122), and the other two

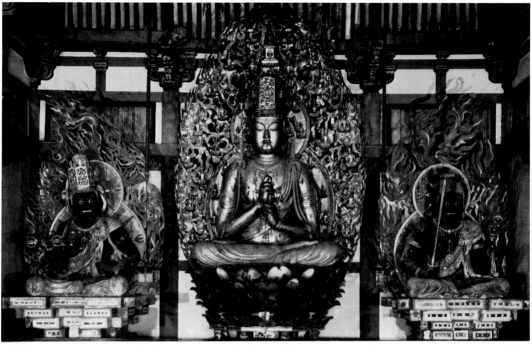

164. Mandala placement of statues, Kongo-ji, Osaka. Left to right: Gosanze Myo-o, Dainichi Nyorai, Fudo Myo-o. Thirteenth century.

portray goddesses (Figs. 129, 165). Although the faces of all three are done in Buddhist-image style, there is a certain indigenously Japanese quality in the shape of these faces, and they do not convey the transcendent feeling that Buddhist statues normally inspire. Moreover, the softness of the bodies suggests that these three works, instead of relying on the older sculptural tradition, draw on the Esoteric Buddhist concepts introduced by Kukai. Temple tradition attributes the statues to the great priest himself, but there is no way of proving that he was the sculptor. Even so, the style hints that the tradition may be correct at least in sense of time. If this is true, the statues would predate the image of the goddess at the Matsuo Shrine.

Despite the lack of documentation concerning the dates of the previously mentioned statues of the goddess Fusumi (Fig. 123) and the god Hayatama no Okami (Fig. 144) at the Kumano Hayatama

Shrine, their size and their carving place them coeval with the works discussed in the preceding paragraph—that is, the early Heian period. Although the goddess is distinctly Japanese and Heian in feeling, the open personality-charged eyes and the foreign-style crown of the god indicate that this divinity may have reached Japan from some other country. In fact, Shinto gods that find representation in sculpture and painting are often naturalized foreign arrivals.

In addition to the statues of officially recognized gods a number of other art forms came to be associated with the faith in Shinto deities adopted by Buddhism. For instance there remain many examples of bronze mirrors—symbols widely used in Shinto shrines—engraved with depictions of Buddhas. In the Kamakura period the Buddha figures were no longer engraved but were executed in high relief. Most of the Kamakura pieces are bronze,

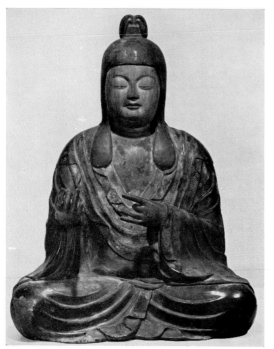

165. *Shinto goddess, To-ji, Kyoto. Painted wood; height, 115 cm. Ninth century.*

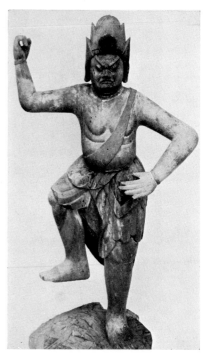

166. *Zao Gongen, Sambutsu-ji, Tottori Prefecture. Wood; height, 110 cm. Late eleventh or early twelfth century.*

167. *Detail from Kasuga Shrine Mandala, Kasuga Shrine, Nara. Colors on silk; dimensions of entire mandala: height, 109 cm.; width, 41.5 cm. Dated 1300.*

but a few wooden reliefs of the same type survive.

I have already had occasion to comment on the mountain faith in Japan. One of the objects of this kind of worship is the god named Zao Gongen, a divinity found in no known sutra, although the form he assumes is clearly based on those of the Five Mighty Bodhisattvas dealt with in the *Ninno-kyo*, the *Sutra of Benevolent Kings*. Zao Gongen was popular with devotees of the mountain faith until the late Kamakura period, when images of him were gradually replaced with those of the famous ascetic priest En no Gyoja.

As a final example of the blend achieved between Buddhism and Shinto, I must mention the mandalas painted for use in Shinto shrines rather than for purposes of Esoteric Buddhist worship (Fig. 167). Sometimes these mandalas depict both the shrine and its protective Buddha, sometimes only one or the other. There are even examples in

which the shrine is shown in total view with large numbers of the faithful trooping toward it. Mandalas of this kind were never produced in numbers comparable to those used in Esoteric Buddhism, and very few of them warrant special mention on the basis of their aesthetic merits.

KANNON AND FUDO MYO-O

No other divinities in Japanese Buddhism ever enjoyed the breadth, depth, and duration of faith among the people that have been accorded to both Kannon and Fudo Myo-o. In consequence of their great popularity, the two have been depicted in a wide variety of forms. It is not strange that the common people should have found these deities especially attractive, for both Kannon and Fudo Myo-o promise protection and genuine advantages in this life. The personalities of the two have much in common with those of Hindu gods. It is even thought that they may have originated from associations with the important Hindu divinity Siva and his consort Parvati—that is, that some of the characteristics of these Hindu gods were incorporated into Buddhist iconology, given the forms of Bodhisattvas, and associated with Kannon, while some were given expression in a new group of divinities, the Kings of Light, or Myo-o, of whom Fudo Myo-o was to become the most revered in Japan.

The Kannon Bodhisattva (also called Kanzeon Bosatsu) already had an extensive following in Indian Buddhism in the third century A.D. In the early fifth century the Indian sage Kumarajiva (in Japanese, Kumaraju) produced Chinese translations of the *Lotus Sutra* and other sutras pertaining to Kannon. Obviously by this time the worship of Kannon had already achieved a certain generality. According to the *Kannon-kyo* (Kannon Sutra), when people in distress pray to this divinity, he will come to their aid in one of his thirty-three forms. Promises of such great advantage are not to be ignored, and the common people found great comfort in devotion to a deity who offered virtually unbounded help. Consequently, as his worship spread, together with faith in the *Lotus Sutra*, Kannon appeared in more variations of his basic manifestation. Some of

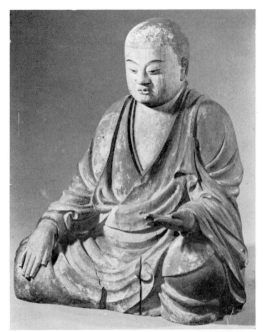

168. *Shinto god Hachiman represented as a Buddhist priest, Yakushi-ji, Nara. Painted wood; height, 39.7 cm. Ninth century.*

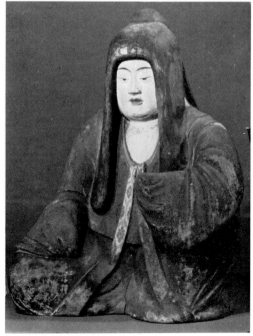

169. *Shinto goddess personifying Empress Jingo, Yakushi-ji, Nara. Painted wood; height, 35.5 cm. Ninth century.*

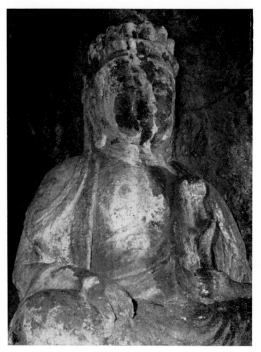

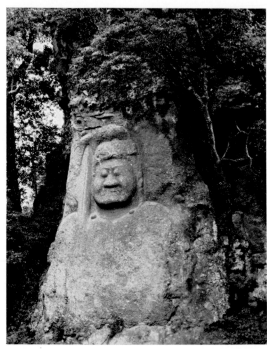

170. *Eleven-headed Kannon, Iwa Gongen, Oita Prefecture. Stone relief; height of entire image, 184.8 cm. Eleventh to twelfth century.*

171. *Fudo Myo-o, Kumano Gongen-sha, Oita Prefecture. Stone relief; height, 8 m. Thirteenth century.*

the most notable of his forms are discussed in the following sections.

THE ELEVEN-HEADED KANNON

The Juichimen Kannon, or Eleven-headed Kannon, is the first manifestation of the deity to depart from the normal human allotment of one head and two arms. The first written records of the Eleven-headed Kannon date from around 570, but it is not known when his worship was first introduced into Japan. Nevertheless, since the divinity was depicted in the famous murals at the Horyu-ji (Fig. 45), it is clear that this form of Kannon was known and revered in the seventh century, when that temple was built. The arrangement of the heads in the Horyu-ji version is different from the one that was later to become standard, for small heads are placed to the right and left of the central one.

As devotion to the Eleven-headed Kannon continued to grow, more statues were required. This explains the large number of excellent figures remaining today from both the late Nara and the Heian periods. The Eleven-headed Kannon was widely worshiped even before the establishment of true Esoteric sects in Japan, but after the foundation of the Tendai sect new Indian influences pervaded representations of this Bodhisattva in sculpture and painting—for example, as seen in the Kogen-ji Kannon (Figs. 49, 56, 73). The exotic style, however, was never warmly received in Japan.

Although the sutras say that the ten subordinate heads must be of the same size (Fig. 55), this was extremely difficult to effect in sculpture in the round. In both China and Japan the recognized standard arrangement became that of three tiers of heads on top of the main one, which is generally

much larger than its fellows. Furthermore, the total number of heads is most often twelve: the main head with a crown of eleven subordinate ones. The Eleven-headed Kannon sometimes has four arms in accordance with a precept established by a Chinese monk of the T'ang period, but there is only one such statue known in India: a representation in a cave temple.

THE FUKUKENJAKU KANNON

Sutras dealing with the Fukukenjaku Kannon, appearing not long after sutras dealing with the Eleven-headed Kannon, were translated into Chinese during the later years of the sixth century. An extensive literature on the Fukukenjaku Kannon exists, and one sutra alone runs to thirty scrolls. This mammoth work, dating from around 709, suggests that worship of the deity was then at its peak. The sutra, incidentally, is the first to mention the paradise of Kannon. The variety of forms in which the Fukukenjaku Kannon may appear is wide. He may have one head and two arms (the most frequent form); four, eight, ten, or even eighteen arms; one head with three eyes; three heads; and sometimes eleven heads. In Japan, however, one head and four arms are considered standard. Records indicate that statues of the Fukukenjaku Kannon were produced in abundance in the late Nara and Heian periods. Outstanding extant examples include the statues in the Hokkedo of the Todai-ji (Fig. 54), in the Lecture Hall of the Koryu-ji (Fig. 172), and in the Lecture Hall of the Toshodai-ji. The present main image in the South Octagonal Hall of the Kofuku-ji is a reproduction, made in 1189, of an original statue dating from 813. As we have noted earlier, the Fukukenjaku Kannon is sometimes shown with a deerskin over his shoulder: a representation interpreted as indicating a connection with the Fujiwara clan and their tutelary shrine of Kasuga, long famous for its herd of tame deer.

THE THOUSAND-ARMED KANNON

As people came to rely more heavily on the blessings and salvation promised by the Bodhisattva Kannon, they came to require a

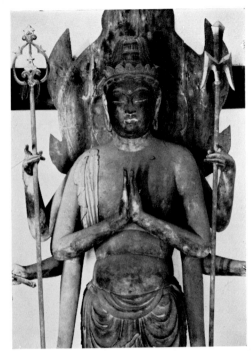

172. *Fukukenjaku Kannon, Lecture Hall, Koryu-ji, Kyoto. Wood; height of entire statue, 314 cm. Late eighth century.*

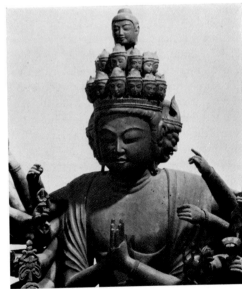

173. *Thousand-armed Kannon, Hossho-ji, Kyoto. Wood; height of entire statue, 109.7 cm. About 924.*

THE THOUSAND-ARMED KANNON · 145

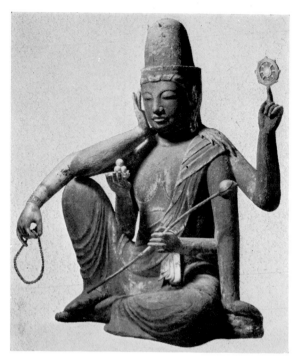

174. Nyoirin Kannon, Anointment Hall, Muro-ji, Nara Prefecture. Wood; height, 77.2 cm. Tenth century.

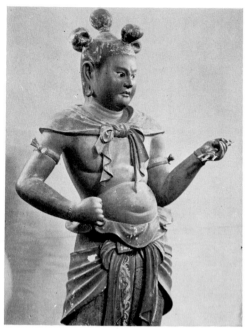

175. Seitaka Doji reputedly carved by Unkei, Fudodo, Kongobu-ji, Mount Koya, Wakayama Prefecture. Painted wood; height, 95.4 cm. About 1198.

Kannon possessed of increasing strength and power. The Thousand-armed Kannon, capable of unlimited miracles, became popular as an answer to this requirement. The first translation into Chinese of scriptures relating to him dates from 649, and the ten later translations of additional material reveal the extent to which he was honored in China and Japan.

Worship of the Thousand-armed Kannon in Japan began in the late Nara period, during which time a priest named Gembo commissioned the copying of a large amount of scriptural material pertaining to this Bodhisattva. Representative Nara-period statues of the deity include the dry-lacquer figures in the Golden Hall of the Toshodai-ji (Figs. 53, 72) and at the Fujii-dera (Fig. 11). In Nara times, attempts were made to give the statues a full complement of one thousand arms, but dur-

ing the Heian period the number was limited to some forty. Heian portrayals of the Thousand-armed Kannon include the statues in the Lecture Hall of the Koryu-ji (Fig. 71), at the Onjo-ji (Figs. 31, 91), and at the Enryaku-ji (Fig. 90). With the passing of time, the popularity of this Kannon increased and spread to regions remote from the capital. Many provincial mountain temples enshrined statues of the deity as main images, but nothing else achieves the level of extravagant devotion displayed by the one thousand and one statues of the Thousand-armed Kannon at the Sanjusan-gendo of the Rengeo-in, in Kyoto (Fig. 59).

In the tenth and eleventh centuries many statues of the Thousand-armed Kannon were produced. One of the most interesting of these is found at the Hossho-ji, in Kyoto. This work (Fig. 173), dated about 924, is crowned with twenty-five heads, of

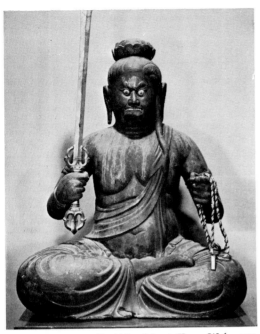

176. *Fudo Myo-o, Shochi-in, Mount Koya, Wakayama Prefecture. Painted wood; height, 95 cm. Ninth century.*

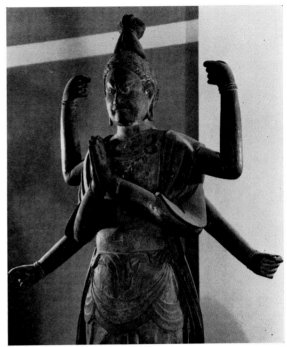

177. *Horse-head Kannon, Daian-ji, Nara. Wood; height of entire statue, 174 cm. Eighth century.*

which the two large ones on either side of the main head are unusual. The modeling of the body strives for some of the fleshy abundance of works of the preceding period but ends in formalization. Furthermore, the facial features follow a largely alien mold that was never to gain wide acceptance in Japan.

THE NYOIRIN KANNON Not only is the Nyoirin Kannon at the Kanshin-ji (Fig. 9) the greatest statue of this Kannon ever produced in Japan; it also represents the pinnacle of all Japanese Esoteric Buddhist art. Seated with one knee raised in the royal-ease posture, with trunk held straight and head slightly inclined to one side, the figure has a soft sensuality that is balanced by the dignity of the pose. Not long after this statue was completed, Esoteric art in

Japan settled into formalization, as the statues of the five emanations of Kokuzo Bosatsu at the Jingo-ji make clear (Fig. 115).

The six-armed version of the Nyoirin Kannon, based on documents and scriptures brought to Japan by Kukai, is found in the Mandala of the Womb World. Other sculptural representations of the divinity include those at the Muro-ji (Fig. 174), the Kanno-ji, and the Daigo-ji. None of these, however, is either as old or as excellent as the Kanshin-ji statue. There are no outstanding paintings of this Bodhisattva.

Sutras pertaining to the Nyoirin Kannon reached Japan as early as the Nara period, and it appears that two-armed representations of the divinity were made in late-Nara times. The main image at the Ishiyama-dera (Shiga Prefecture), founded by the great priest Roben in the mid-eighth century,

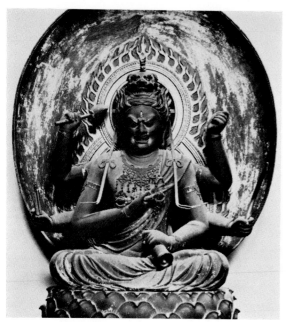

178. Aizen Myo-o, Konzo-in, Mount Koya, Wakayama Prefecture. Painted wood. Thirteenth century.

Bato (Horse-head) Kannon is worshiped largely in mountainous regions, where stone images of him are often found beside roads. He usually appears in ferocious form with a horse's head surmounting his own (Figs. 30, 177).

From what I have said in the foregoing discussion of Kannon, the multiplicity of the deity's manifestations in Japan should be clear. One must not think, however, that these forms are in any way limited to Japan. Wherever he was worshiped—in India, China, or Tibet—Kannon has always assumed many shapes symbolic of his many powers. But not even Kannon revealed the diversity of features within a single manifestation or the abundance of representations of high artistic quality that one finds in Japanese statues of Fudo Myo-o.

FUDO MYO-O Causes for the wide variety in statues of Fudo Myo-o are two. First, this deity has been popular in Japan for a very long time. Second, he has never fallen into clearly defined categories, as has Kannon, and therefore, within a single general pattern, it has been possible to give him a considerable number of varying representations.

The first mention of Fudo is made in the *Fukukenjaku-kyo*, where he is described as a messenger of the Buddhas. He does not receive the designation Myo-o, or King of Light, until his appearance in the *Dainichi-kyo*. Later, however, a sutra devoted solely to Fudo Myo-o was composed. All of these writings are old enough for people in the Nara period to have known about the divinity, but there are no records indicating that statues of him were made during that time. The first wide-scale attention paid to him in Japan resulted from the efforts of Kukai and his followers.

Although Fudo Myo-o originally held no more exalted position than that of servant, he was empowered with great strength to subdue wicked passions. In addition, he was believed to display tremendous might when invoked in prayer. Hence he was awarded the designation Myo-o, or King of Light, in which title "light" has the meaning of "knowledge." His body, which is soft and childish,

was a two-armed Nyoirin Kannon. The original was destroyed by fire in 1078, and the present statue was made for a reconstruction of the temple ordered in the late twelfth century by the military ruler Minamoto Yoritomo. Another and very large statue of this divinity, thought to date from the Nara period, exists today at the Oka-dera, in Nara (Fig. 33). It is made of clay, and only the head remains in its original form, for the body has been much repaired.

THE BATO KANNON Although both of these
AND THE JUNTEI deities appear in Bud-
KANNON dhist scriptures as early
 as the beginning of the
seventh century and although statues of the Bato Kannon were made in Japan in the Nara period, neither achieved wide popularity among the Japanese. There are very few extant statues of the Juntei Kannon, a feminine form of the Bodhisattva. The

as befits a messenger boy, lacks the thirty-two distinguishing marks of the Buddhas and the Bodhiattvas. His eyes are out of balance, and his teeth thrust outward in disarray in his small wrinkled face. His hair is worn in a kind of plait hanging down on one shoulder. This last trait and the flower usually adorning his head suggest the coiffures of ancient Hindu servants.

An interesting transformation took place in the facial expression of Fudo after his introduction into Japan and the subsequent growth in his popularity there. This change seems to have occurred only in Japan, for statues of Fudo are uncommon in China, and nothing remains in India to indicate a similar process. It is seen in the softening of his intense fury as described in the sutras to a calm but firm anger directed against all wickedness. Of course, a detailed tracing of the change is beyond the limits of this book, but even a quick look at the following representations should make my meaning clear: the Red Fudo (Fig. 13), the Fudo in the Lecture Hall of the To-ji (Fig. 111), the Blue Fudo (Fig. 119), and the Namikiri Fudo (Fig. 107). The transformation required many years and reflects the spread of faith in this divinity from the aristocrats to the common people. So popular did Fudo become that many remote mountain temples contain images of him, and there are numerous relief carvings of him in caves (Fig. 68).

To symbolize his authority, childish figures of his attendants Kongara and Seitaka usually accompany Fudo (Figs. 13, 119, 126, 128). Sometimes, though not often, his youthful assistants number three, five, or even eight. The statue of Seitaka Doji shown in Figure 175 is from a set of eight attendants (Hachi Dai Doji) of Fudo.

OTHER MYO-O
REPRESENTATIONS
Deities bearing the title Myo-o are quite numerous in Buddhist scriptures, although only a few of them ever found wide recognition in Japan. Among those who did, Fudo Myo-o ranks far ahead of all others. Next come the Five

Myo-o, of whom Fudo himself is one, and the Peacock (Kujaku) Myo-o. Fudo's anger, as we have noted, is softened and modified in Japan, and the Peacock Myo-o, perhaps the oldest of all deities holding the title, exhibits no wrath at all as he sits on his gorgeous mount, adorned with the costume and jewels of a Bodhisattva (Figs. 179, 180). The remaining Kings of Light, on the other hand, rage with undisguised vehemence in their struggle against wickedness. (Figs. 66, 67, 76, 77).

The Five Great Kings of Light are arranged with Fudo in the middle and one king at each of the four corners: Gosanze (Trailokyavijaya) in the east, Gundari (Kundali) in the west, Daiitoku (Yamantaka) in the south, and Kongo Yasha (Vajrayaksa) in the north. This grouping seems to be entirely Chinese, for there is no Indian scriptural basis for it. Furthermore, there is little common relationship to link the five quite individually evolved divinities. For instance, whereas in the *Diamond Crown Sutra* it is Gosanze Myo-o who subdues Siva and his consort Parvati, in the *Dainichi-kyo* it is Fudo Myo-o who performs this feat. Daiitoku Myo-o is a Buddhist version of a Hindu god of the world of the dead, and as such he is related to Emma Ten (Yama) and Emma O (Yamaraja), both kings of the afterlife. Fudo Myo-o, profoundly but calmly angry with evil, is the most suitable deity to bind together this group of diverse personalities whose sole intrinsic uniting feature seems to be fury. Nowhere in the group is this rage more boldly portrayed than in the multiple-headed Kongo Yasha (Figs. 66, 116).

The last of the Myo-o with whom I shall deal is Aizen, an interesting symbolization of the hope of attaining Buddhahood without denying the passions native to human flesh. To underscore this symbolism, Aizen's body is brilliantly, carnally red, and behind him is a flaming crimson aureole (Fig. 178). This Myo-o was especially popular after the Heian period, and Kamakura-period depictions of him were sometimes a blend of his traits and those of Fudo Myo-o.

The Distinctive Features of Esoteric Buddhist Art: A Summary

I AM AFRAID THAT the general opinion of the art of Esoteric Buddhism runs something like the following: "In the Heian period, Esoteric art was imported. When that happened, the kinds of Buddhist statues and the variety of their expressions increased. In order to make distinctions among all of them clear, it became essential to resort to a complicated array of hand positions and accessory objects. Finally, as a consequence of all this, Japanese art entered a phase of undesirable formalization necessitated by the demands of Esoteric art."

There is no denying the grain of truth in this opinion. Yet, if one attempts to examine the subject in greater detail, with an eye to the characteristics of art itself, what emerges?

Kukai said that color and form were essential to the teaching of the ideals and profound, hidden meanings of Buddhism. Perhaps this is true of all religions, but the artistic expressions used to achieve this end depend entirely on the content of the religion being expressed. Therefore aesthetic methods perfectly suited to the doctrines of Exoteric, or revealed, Buddhism fail to fit Esoteric Buddhism. This, of course is as pertinent to profound aesthetics as to superficial expression.

In the opening section of this book I contrasted the aims of Exoteric and Esoteric Buddhist art. The former strove to give physical form to the vast paradises in which the Buddhas dwell; the latter devoted maximum attention to the rites and disciplines that lead human beings to Buddhahood in this life. In addition, Esoteric Buddhism, in its constant battle to subdue internal and external evils, resorted to devotional images with an actual sensual appeal and to multifarious variations in the forms of these images. The fierce, glaring statues are only one example of this approach. The primary concern in the design of Esoteric religious statues and paintings was to inspire in the heart of the worshiper a profound feeling that the deities stood before him exactly as if they had sprung full-fledged from the mandala on the altar top. Connected with this aim is the Heian style of painting in which the figure is all-important: no background design is needed or wanted.

Emphasis on the benefits to be derived in this life from the worship of certain deities frequently resulted in the idea that these deities were beings quite remote from humanity. When this happened, the artistic representations of the deities grew to

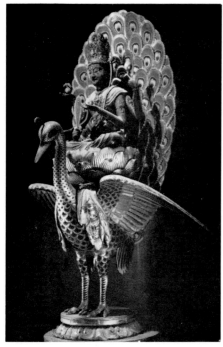

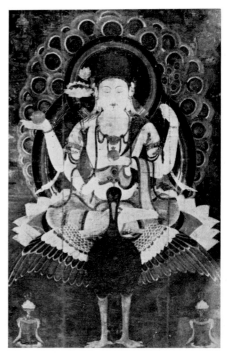

179. *Kujaku Myo-o carved by Kaikei, Kujakudo, Kongobu-ji, Mount Koya, Wakayama Prefecture. Painted wood; height, 78.5 cm. Dated 1200.*

180. *Kujaku Myo-o, Commission for the Protection of Important Cultural Properties, Tokyo. Colors on silk; height, 148.8 cm.; width, 98.8 cm. Second half of twelfth century.*

much larger size than was customary in Esoteric art in its purest form. The huge Thousand-armed Kannon statues are a case in point, but they represent more an indigenous Japanese attitude toward religion than embodiments of true Esoteric Buddhist thought.

The mandala also underwent a certain naturalization after its first introduction into Japan. The space of the formally arranged figures in the mandala is generally plane rather than dimensional, but the space it symbolizes is dimensional beyond all bounds—that is, the mandala is a symbol of the entire Buddhist cosmos. As I have said, a mandala may be a composite of many figures, or it may deal with only one, as does the section of the Mandala of

the Diamond World shown in Figure 14. In the latter case the figure is usually surrounded by a circle, but sometimes rock forms and horizon lines are found in the background. This purely Japanese departure is only one of the many to be found in Esoteric art in Japan after the middle of the Heian period.

In fact, when we compare the Esoteric art of Kukai's time with that produced after middle Heian, we can see the considerable extent to which imported concepts were transformed through Japanese interpretations. As they had done in the case of earlier Buddhist art, the Japanese created from the foreign art of Esoteric Buddhism an art peculiarly their own.

TITLES IN THE SERIES

Although the individual books in the series are designed as self-contained units, so that readers may choose subjects according to their personal interests, the series itself constitutes a full survey of Japanese art and will be of increasing reference value as it progresses. The following titles are listed in the same order, roughly chronological, as those of the original Japanese editions. Those marked with an asterisk (*) have already been published or will appear shortly. It is planned to complete the English-language series in 1977.

The "weathermark" identifies this book as having been planned, designed, and produced at the Tokyo offices of John Weatherhill, Inc., 7-6-13 Roppongi, Minato-ku, Tokyo 106. Book design and typography by Meredith Weatherby and Ronald V. Bell. Layout of photographs by Ronald V. Bell. Composition by General Printing Co., Yokohama. Color plates engraved and printed by Nissha Printing Co., Kyoto. Gravure plates engraved and printed by Inshokan Printing Co., Tokyo. Monochrome letterpress platemaking and printing and text printing by Toyo Printing Co., Tokyo. Bound at the Makoto Binderies, Tokyo. Text is set in 10-pt. Monotype Baskerville with hand-set Optima for display.